BODY *and* SOUL

BODY
and

Black Erotica by Rundū

Crown Publishers, Inc., New York

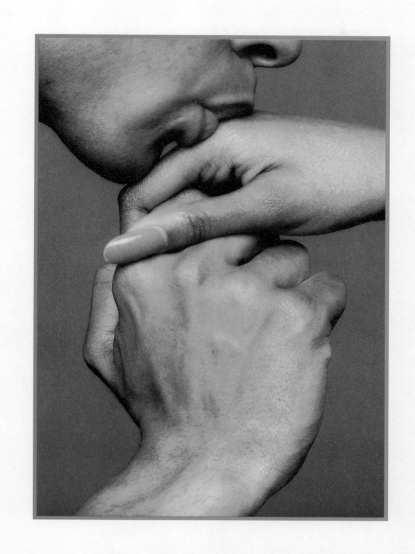

SOUL

Grateful acknowledgment is made to the following for permission
to reprint previously published material.

MAYA ANGELOU: "Country Lover" is reprinted from *And Still I Rise* by Maya
Angelou. Copyright © 1978 by Maya Angelou. Reprinted by permission of
Random House, Inc.

MICHAEL DATCHER: "On Edge." Copyright © 1996 by Michael Datcher.
Reprinted by permission of the author.

PETER HARRIS: "Love Is Our Nationality." Copyright © 1996 by Peter Harris.
Reprinted by permission of the author.

LAINI MATAKA: "Next Door" is reprinted from *Never as Strangers* by Laini
Mataka. Copyright © 1989 by Laini Mataka. Reprinted by permission of Black
Classic Press.

E. ETHELBERT MILLER: "Untitled." Reprinted by permission of the author.

SONIA SANCHEZ: "Haiku" is reprinted from *Under a Soprano Sky,* Africa World
Press, by Sonia Sanchez. Copyright © 1987 by Sonia Sanchez. Reprinted by
permission of the author.

NTOZAKE SHANGE: "The Beach with Okra & Greens" is reprinted from
A Daughter's Geography by Ntozake Shange. Copyright © 1983 by Ntozake
Shange. Reprinted by permission of St. Martin's Press.

Published by Crown Publishers, Inc., 201 East 50th Street, New York, New
York 10022. Member of the Crown Publishing Group.

Random House, Inc. New York, Toronto, London, Sydney, Auckland

http://www.randomhouse.com/

CROWN is a trademark of Crown Publishers, Inc.

Designed by Cassandra J. Pappas

Printed in Singapore

Library of Congress Cataloging-in-Publication Data
is available upon request.

ISBN 0-517-70354-8

10 9 8 7 6 5 4 3 2 1

First Edition

*This book is dedicated to God
and my parents, Tommie and Verdie Staggers;
my brothers, William, Tony, Andre, and Chip;
my loving, supportive relatives;
and my Mentor*

ACKNOWLEDGMENTS

Special thanks to my literary agents Denise Stinson and Charlotte Sheedy. The Crown Publishers family, especially John Clark and Michael Denneny. Also thanks to Wilbor Colom, Santra "Stat" Wiggins (the best friend a person can have), Dave Henderson, Steve Richardson (what would I do without you guys?), Rochelle Howard, Jonothan King, the Wiggins family in Memphis, Tony Barrs, Jace Gatewood, Sheila Poole, Eric Weems, Terrance Davidson, and the fantastic men and now women of our Rundū Style calendars—past, present, and future. Special, special thanks to Bettye Freeman, the writers whose beautiful erotic poety appears in *Body and Soul,* and the wonderful men and women photographed in this book.

BODY *and* SOUL

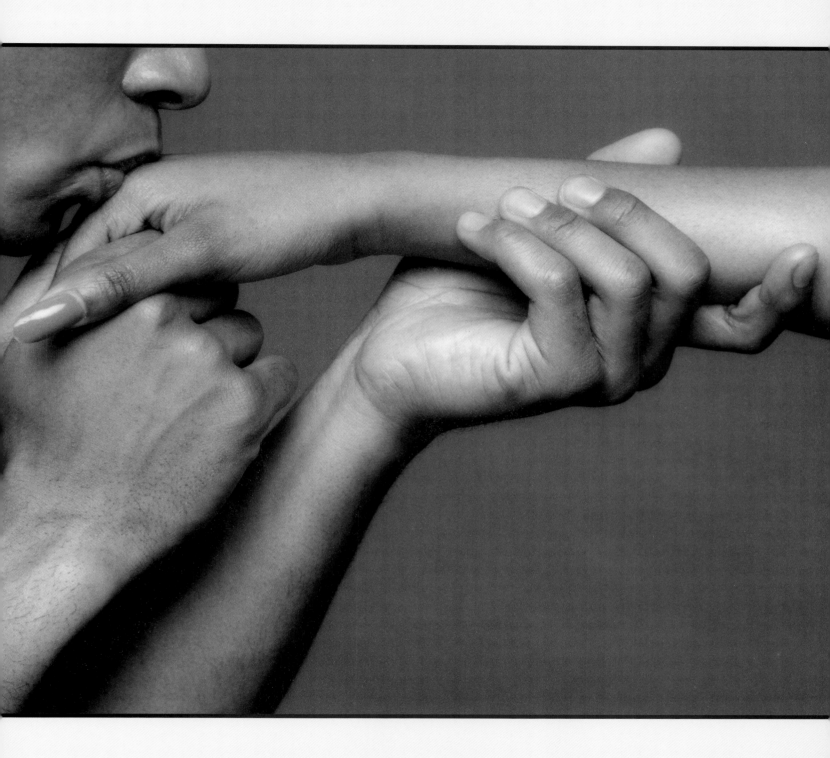

COUNTRY LOVER

Funky blues
Keen toed shoes
High water pants
Saddy night dance
Red soda water
and anybody's daughter

Maya Angelou

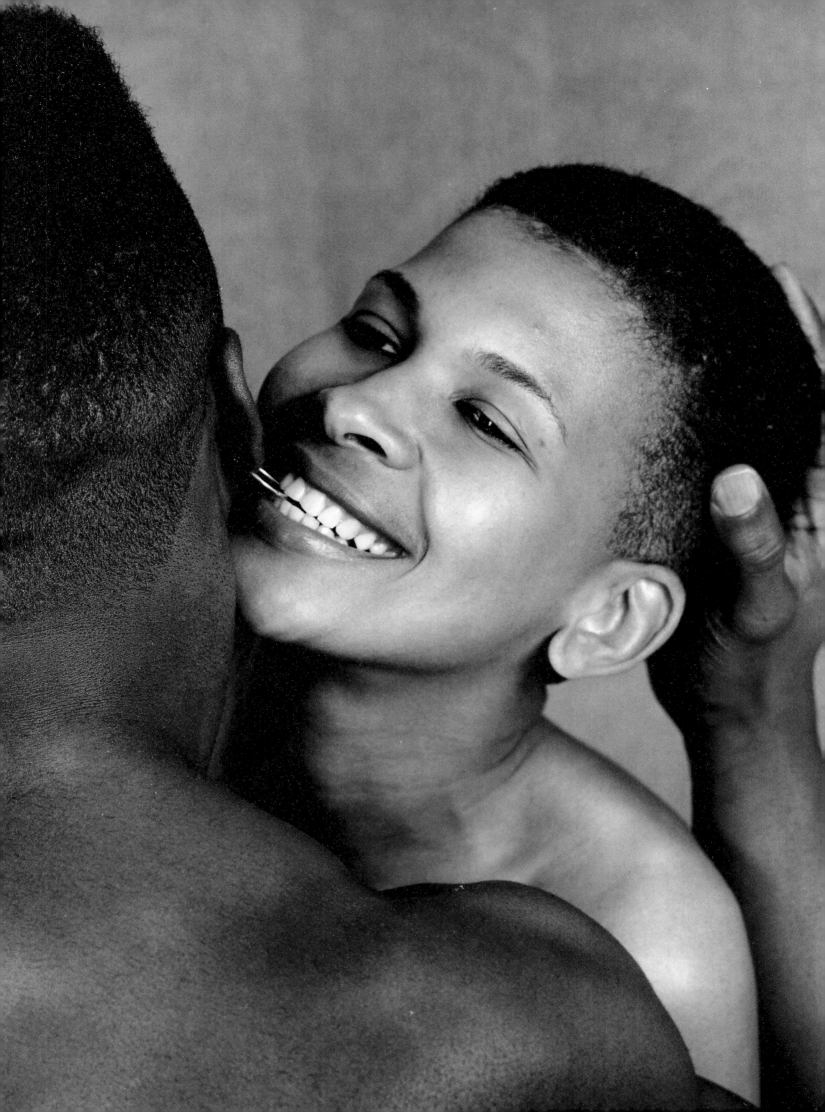

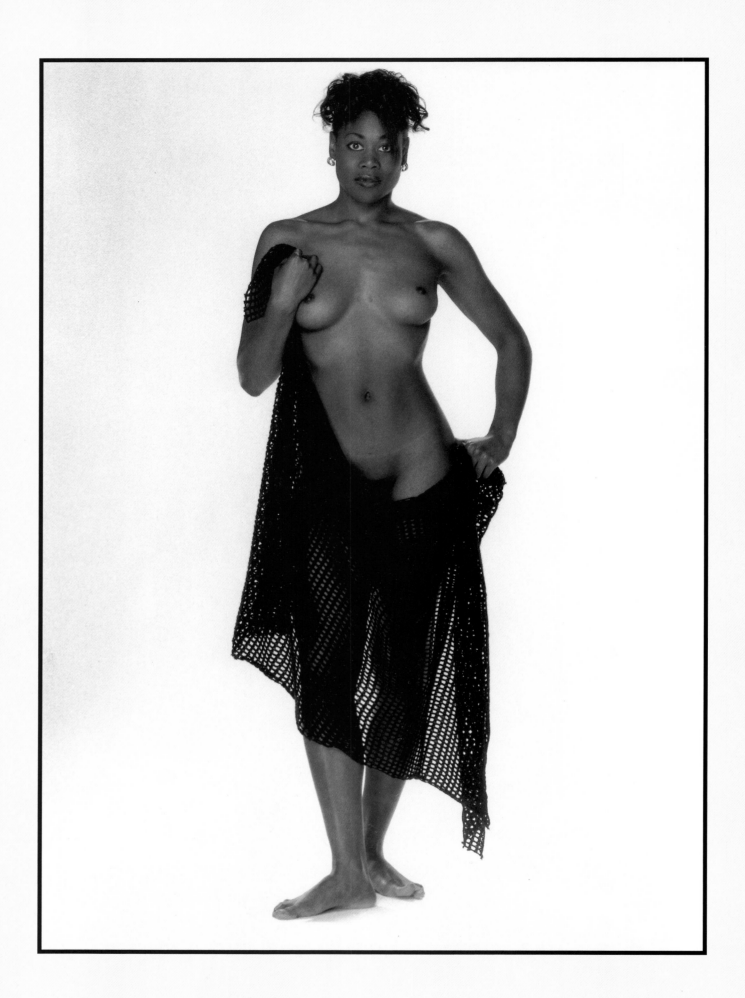

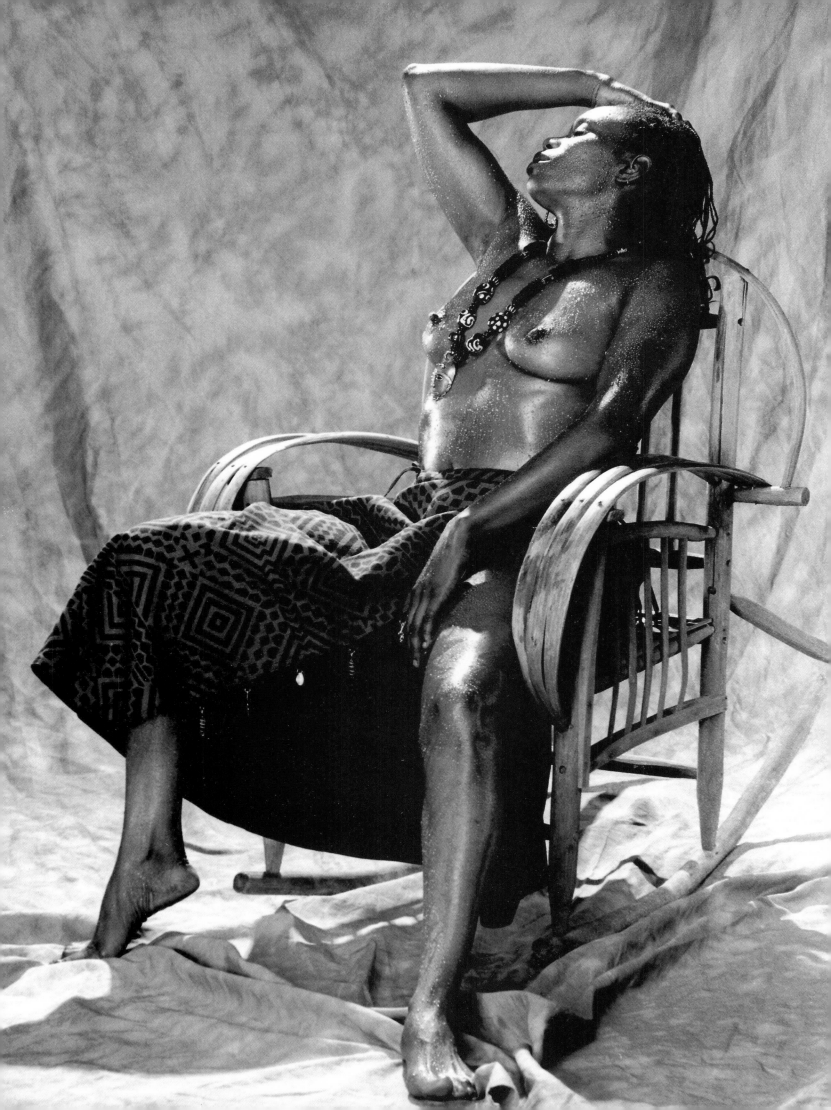

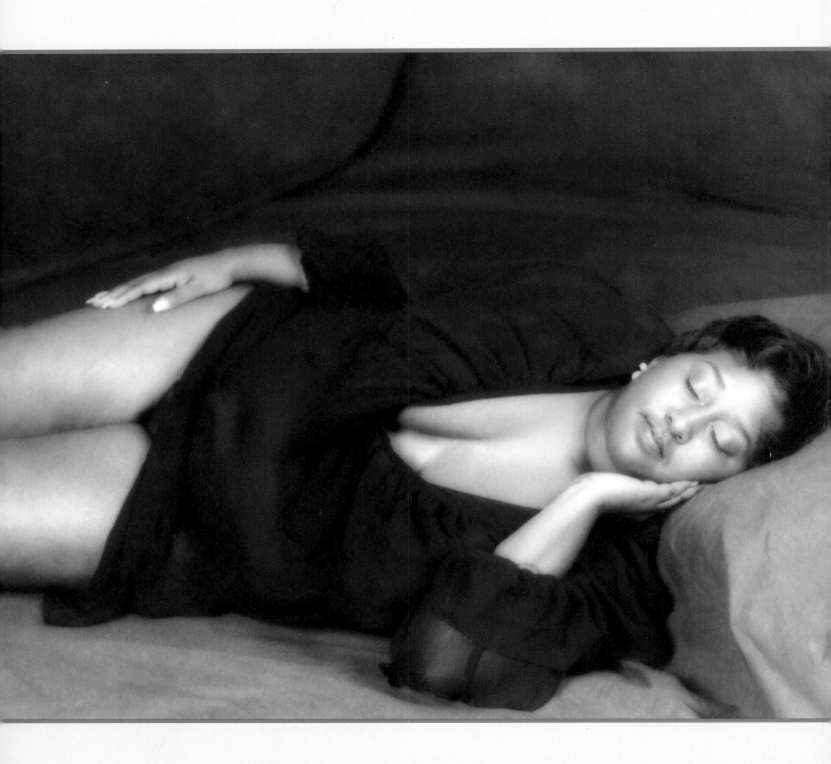

14

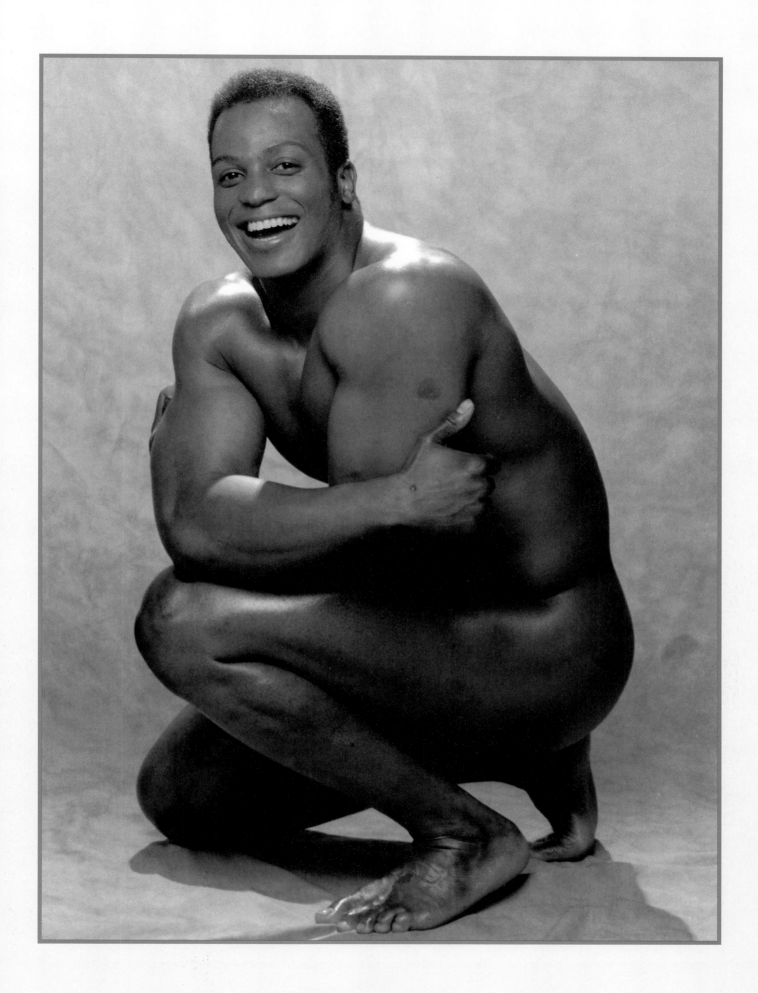

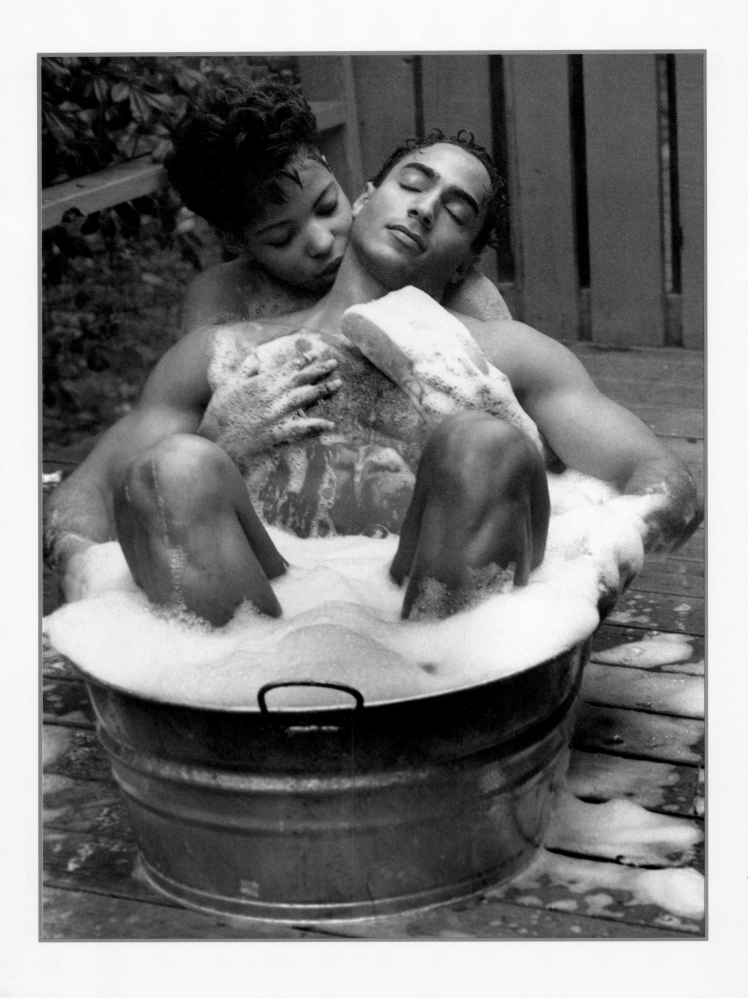

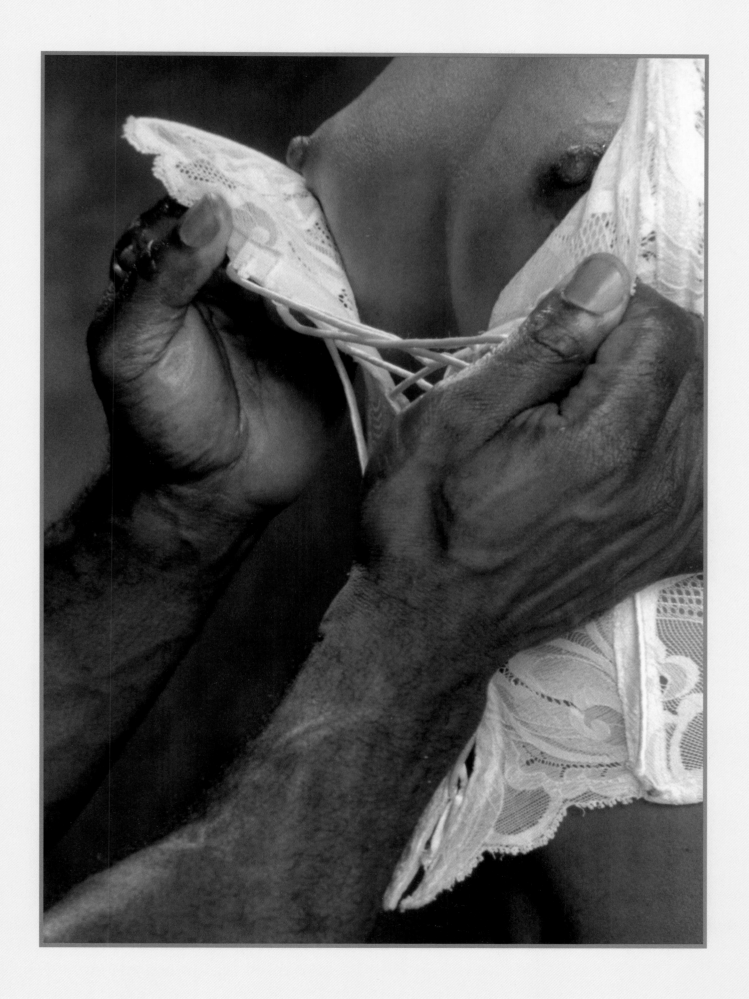

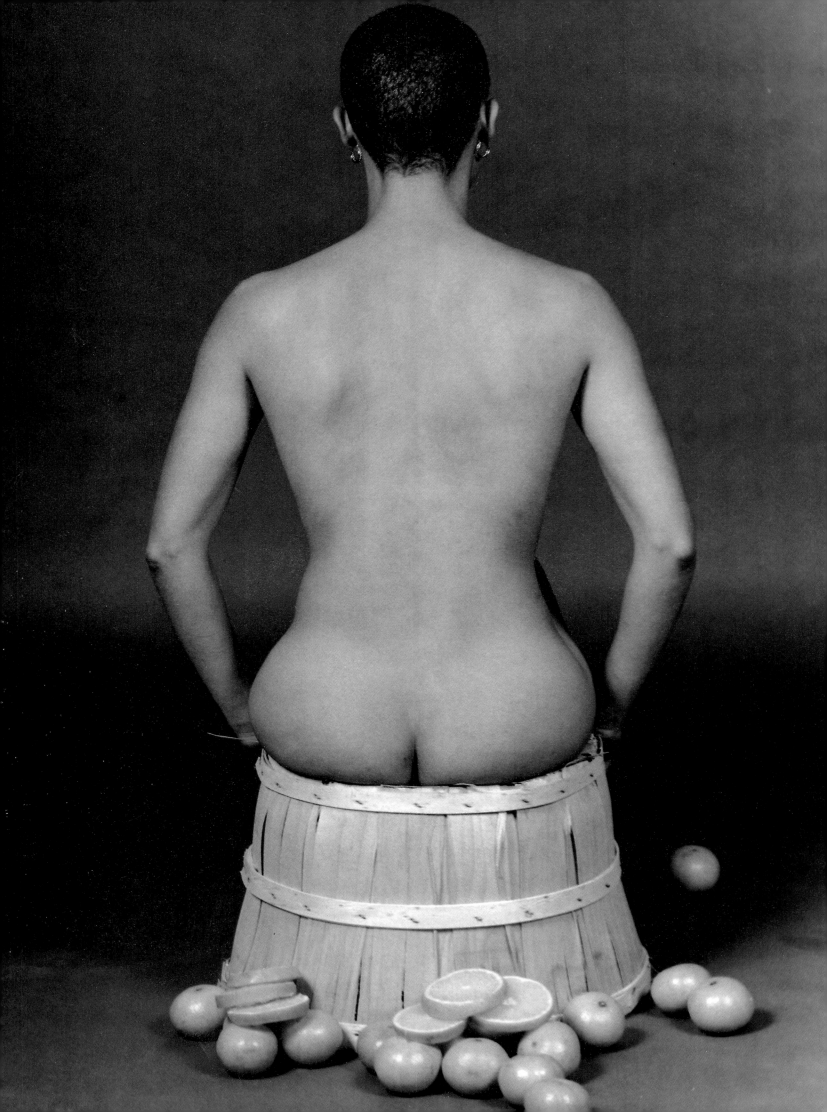

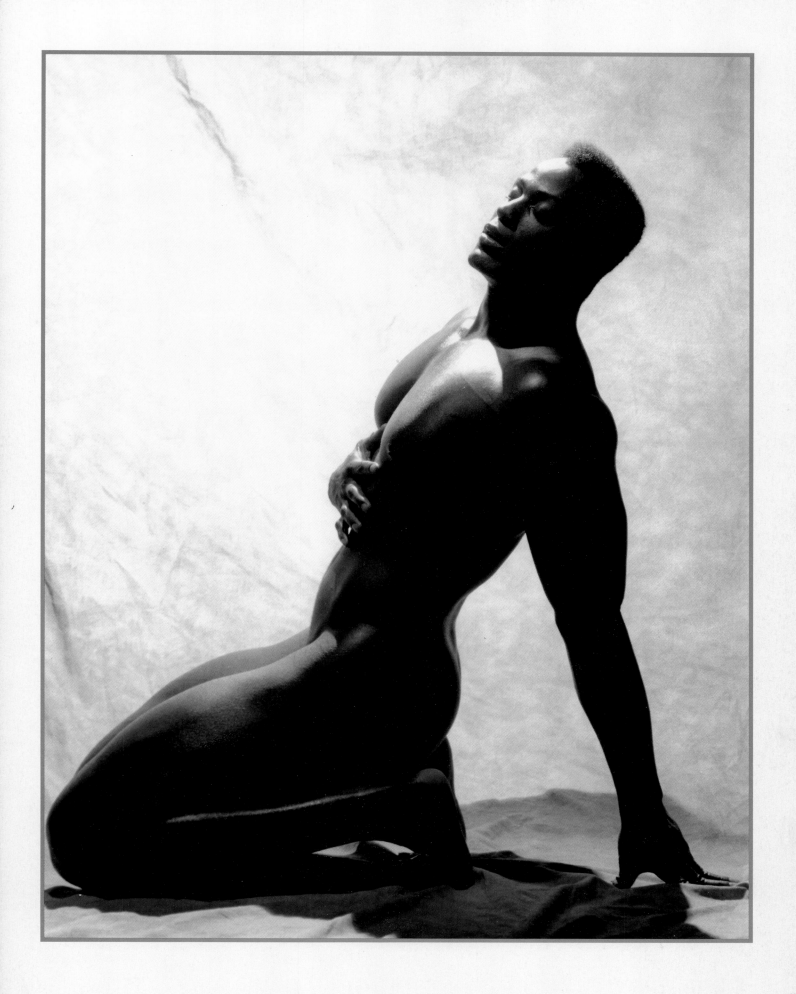

NEXT DOOR

So she sd, if u lose me, u lose a good thing.
and he sd, u're right
but there are so many good things
what cld the loss of one good thing be to me.
and she sd yeah, somebody else may groove u, but
nobody will ever luv u like i do.
and he sd, baby that might be true
but the things that these young girls can do, make
a man like me forget about luv and u.
and she sd, well if u feel like that f—k u too
and before she cld make it to the door he was at
his usual place on the floor cryin:
 baby, c'mon baby
and baby wld come
all week, until he messed things up
by stayin out all night.
mornin wld break un-evenly
and she wld say,
 u kno, if u lose me. . . .

Laini Mataka

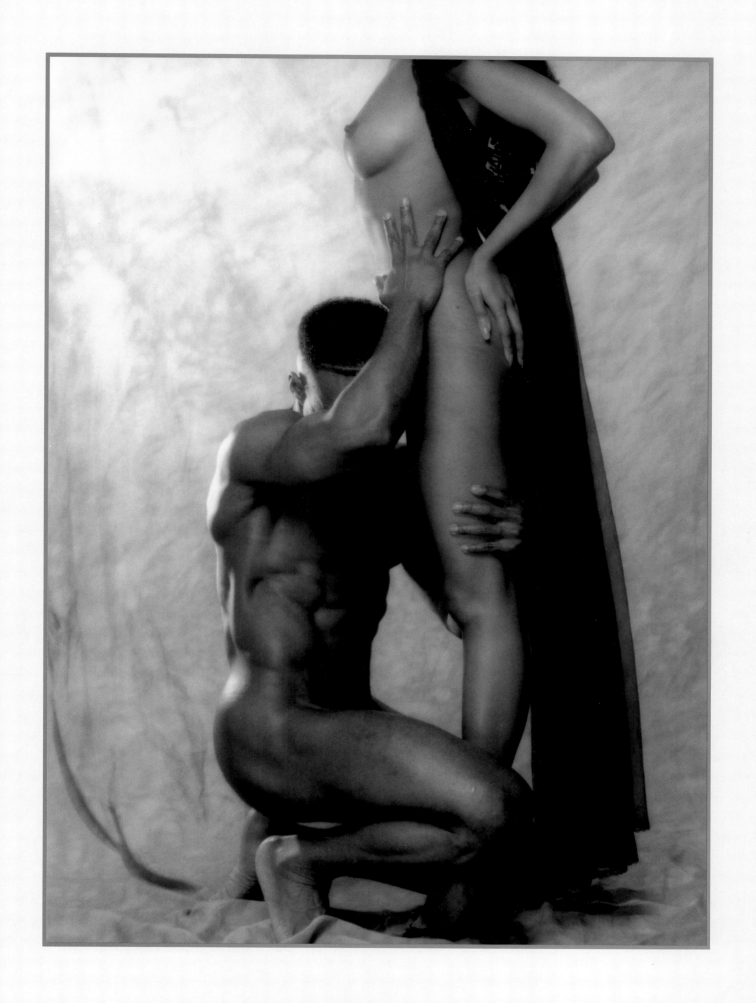

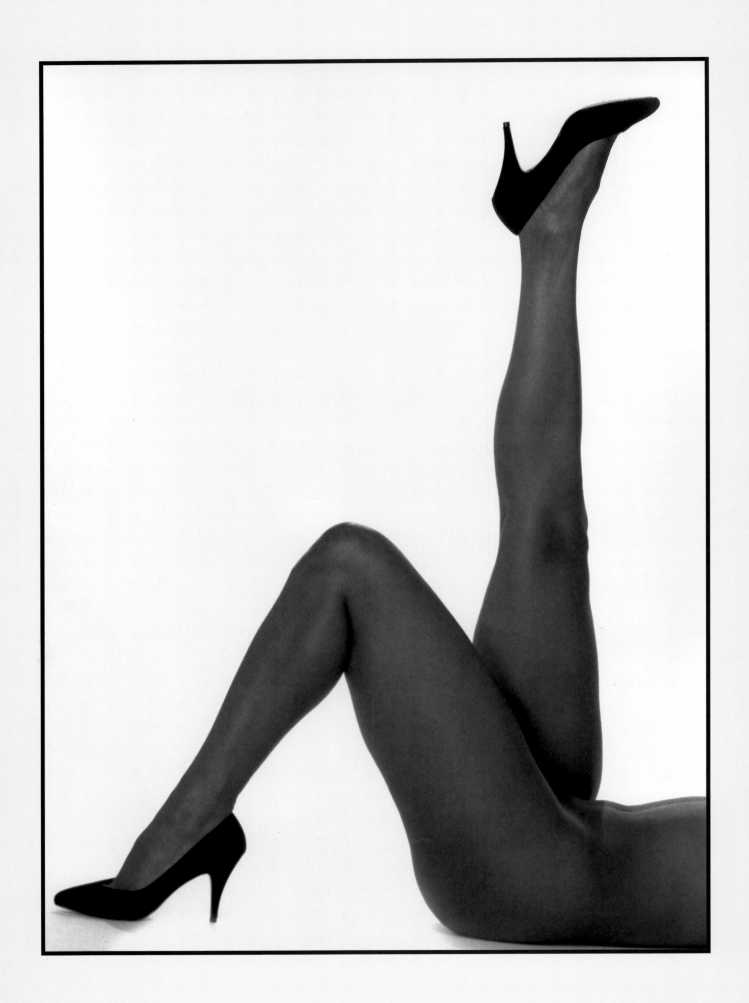

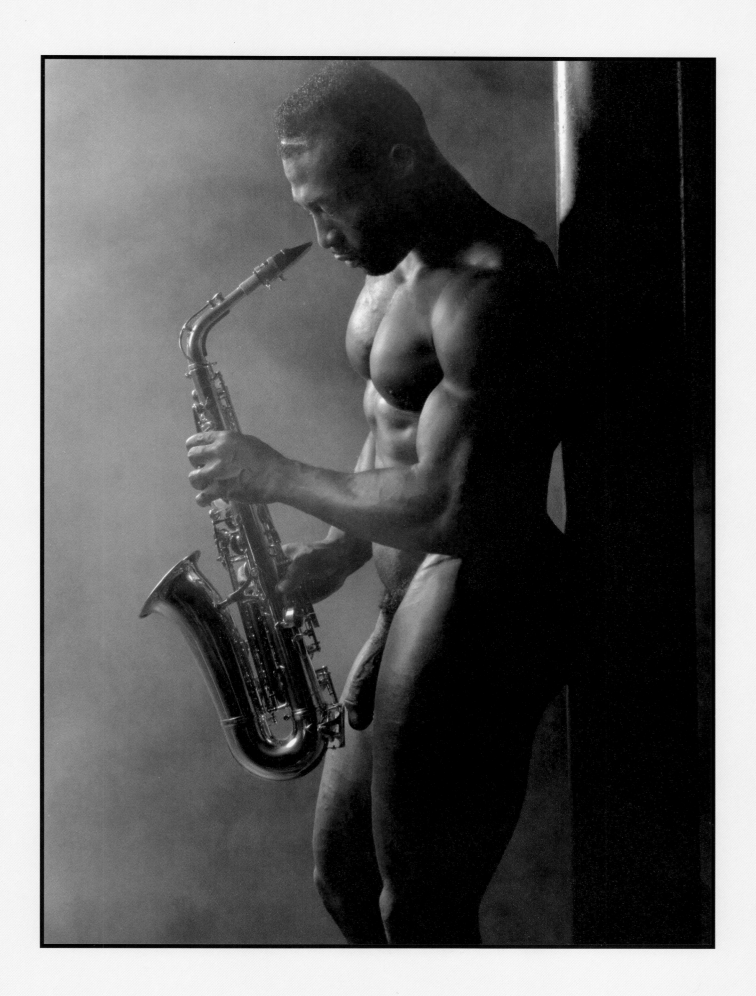

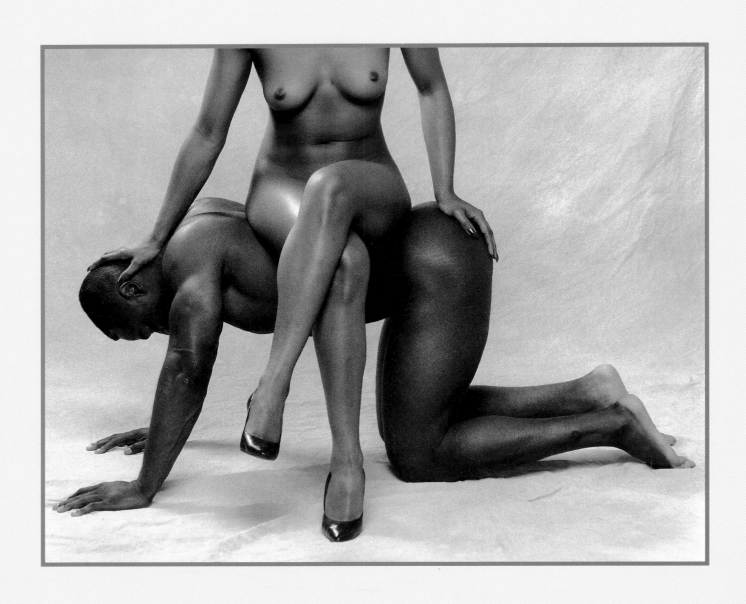

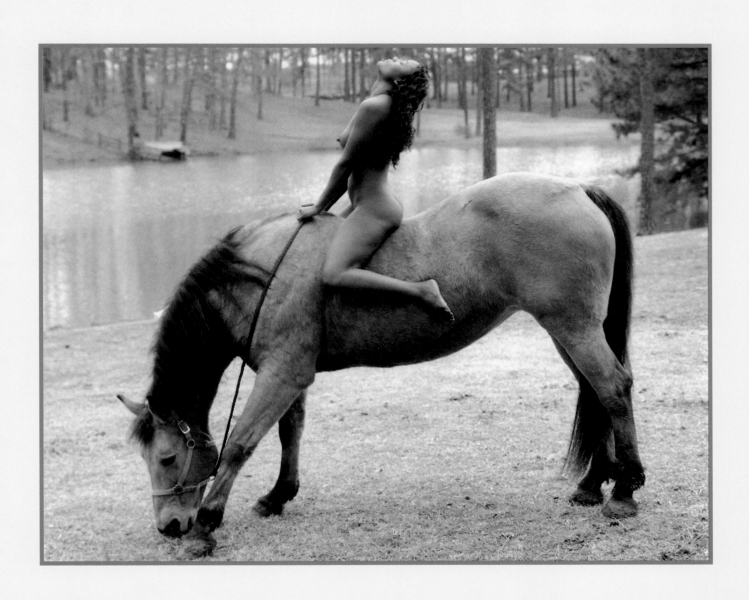

HAIKU

I want to make you
roar with laughter as i ride
you into morning.

Sonia Sanchez

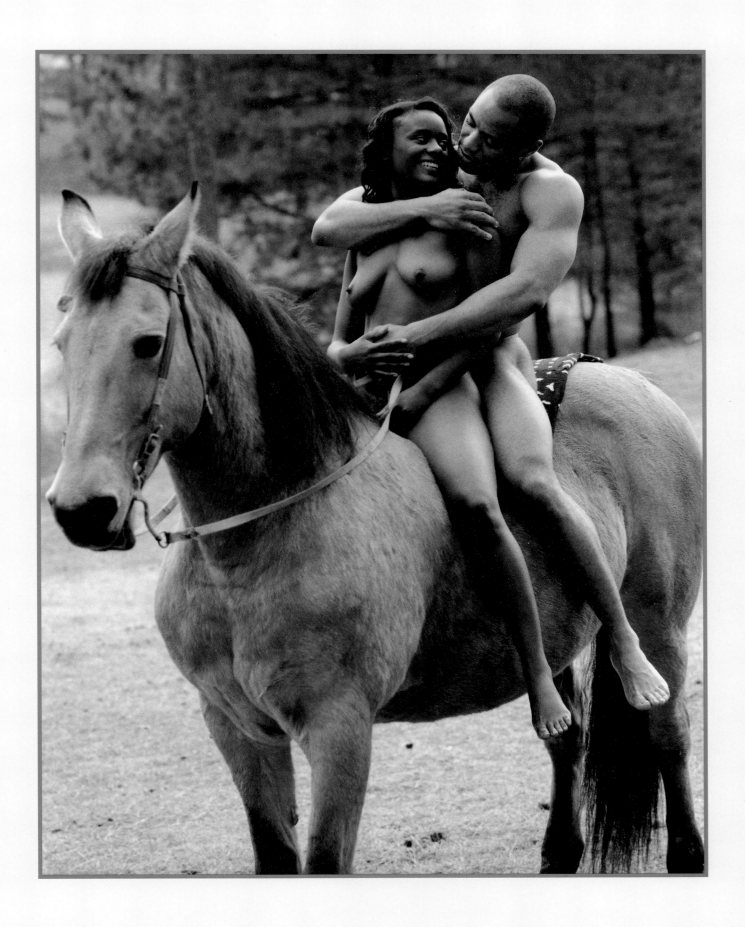

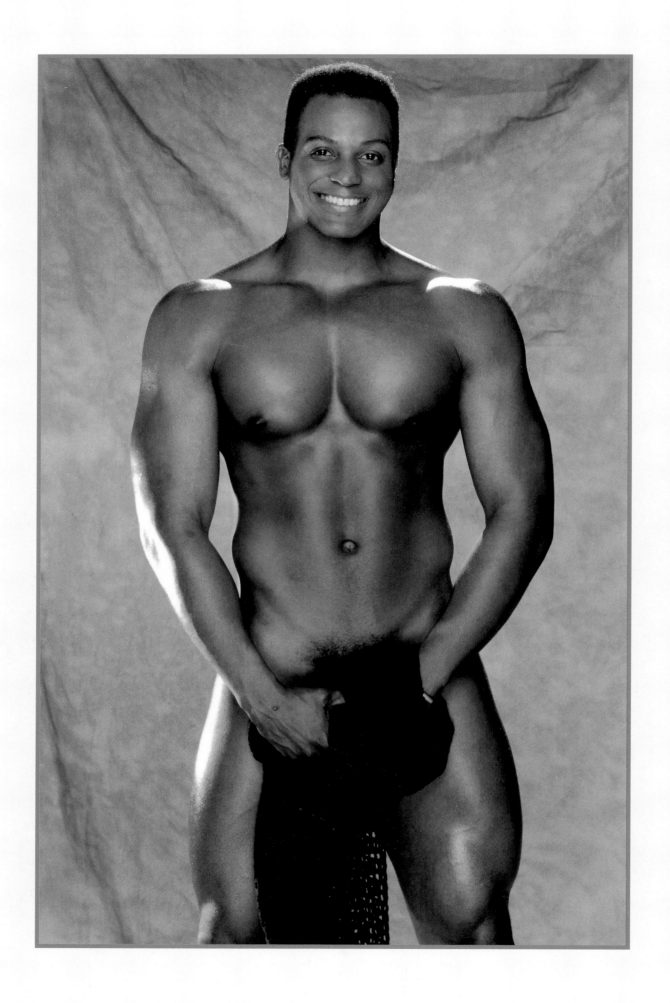

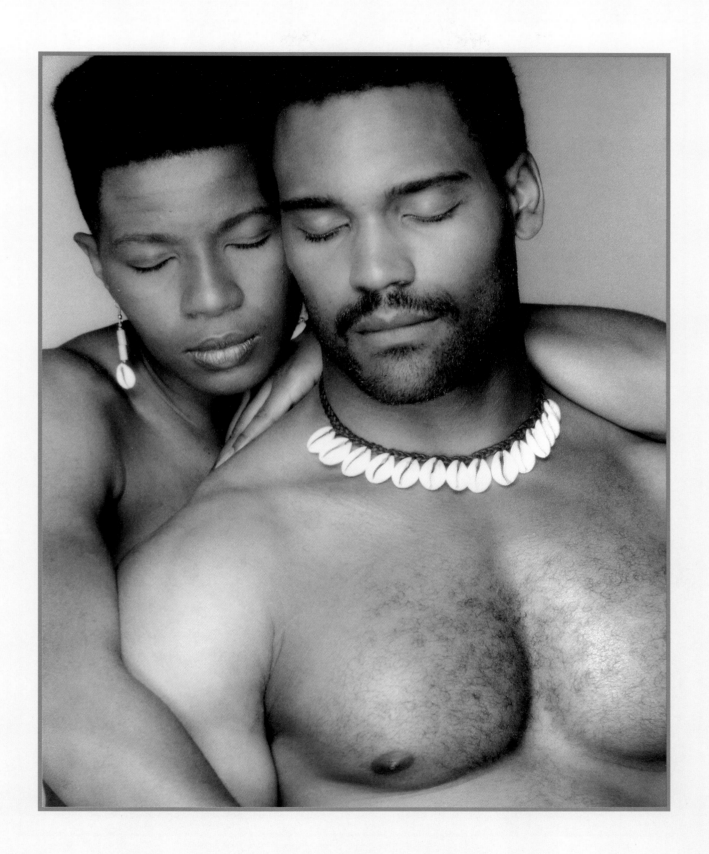

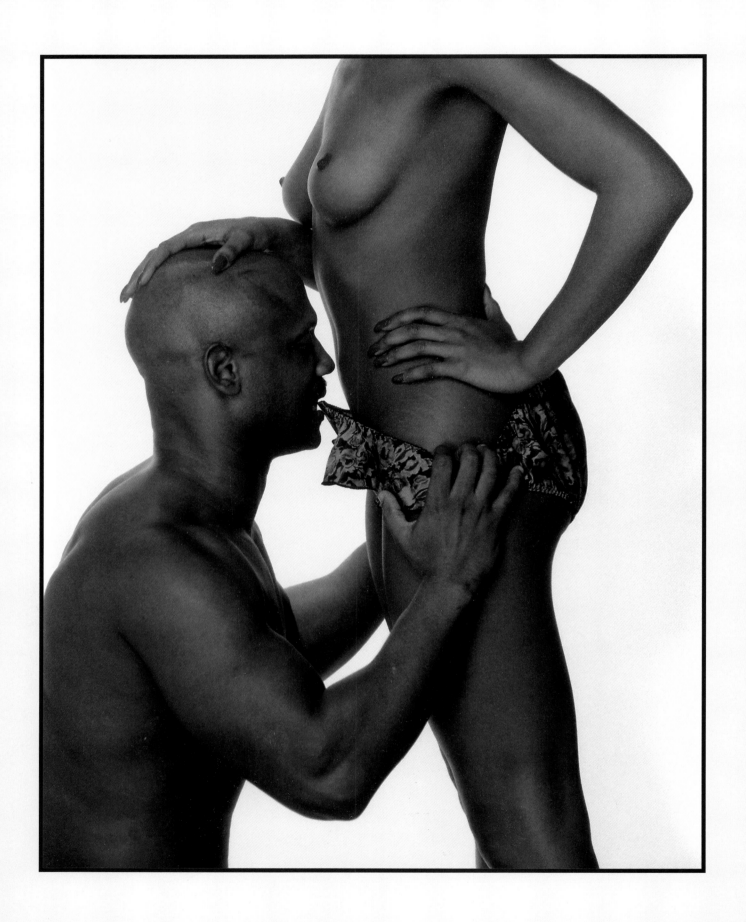

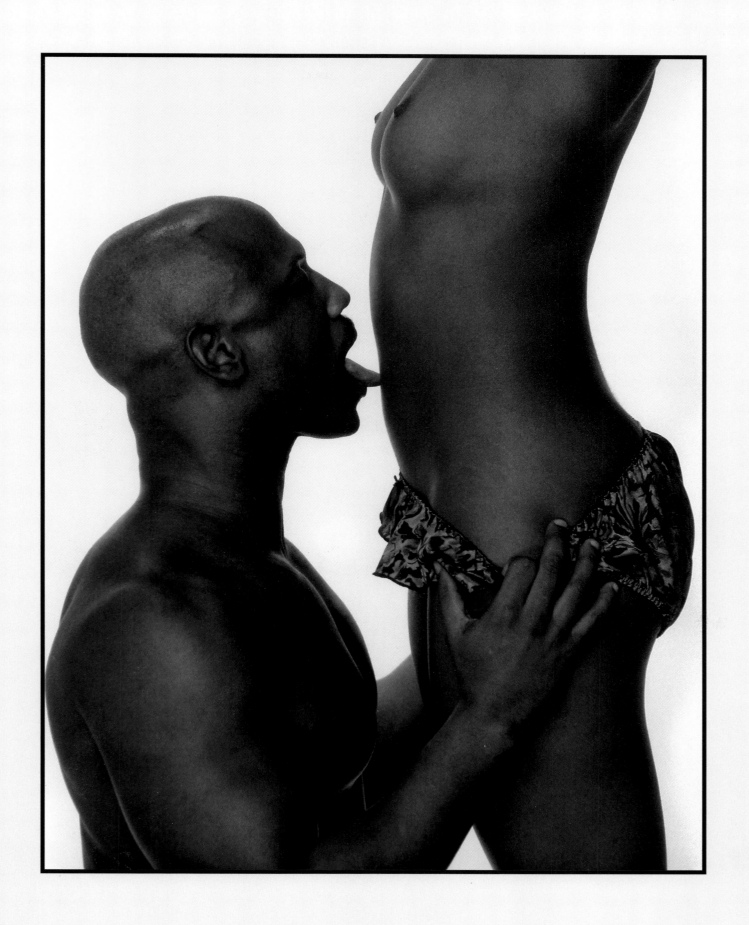

The first time I saw your back
I knew I was in love
the back of you
the smooth space where a man
could place his hands
the two of them
tracing the path down
the steps of your spine

E. Ethelbert Miller

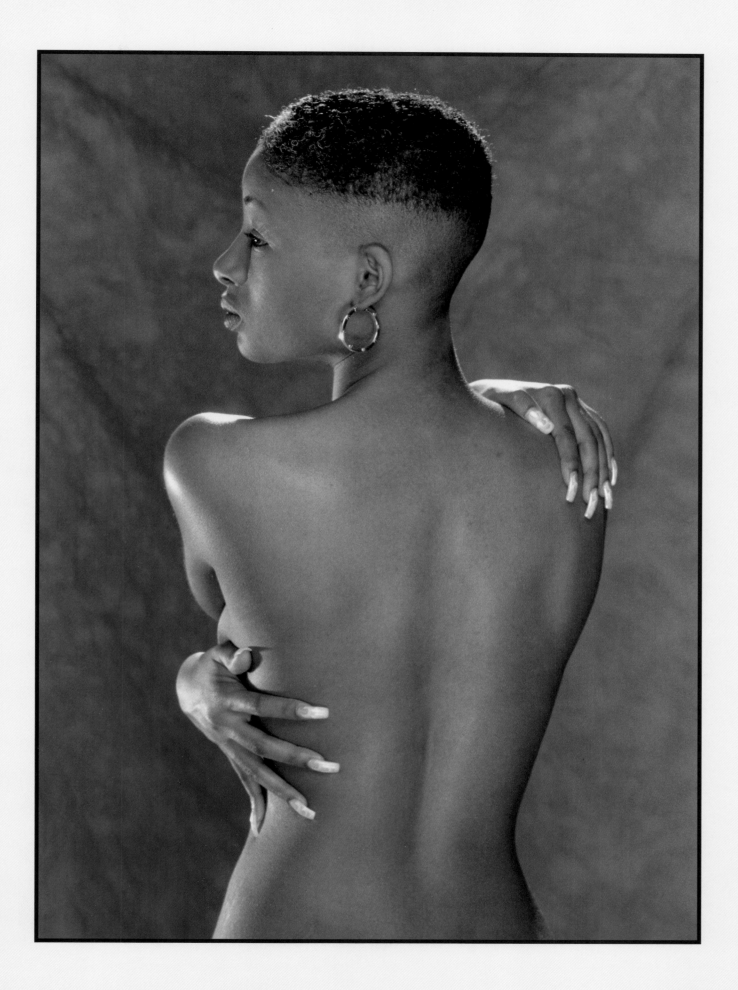

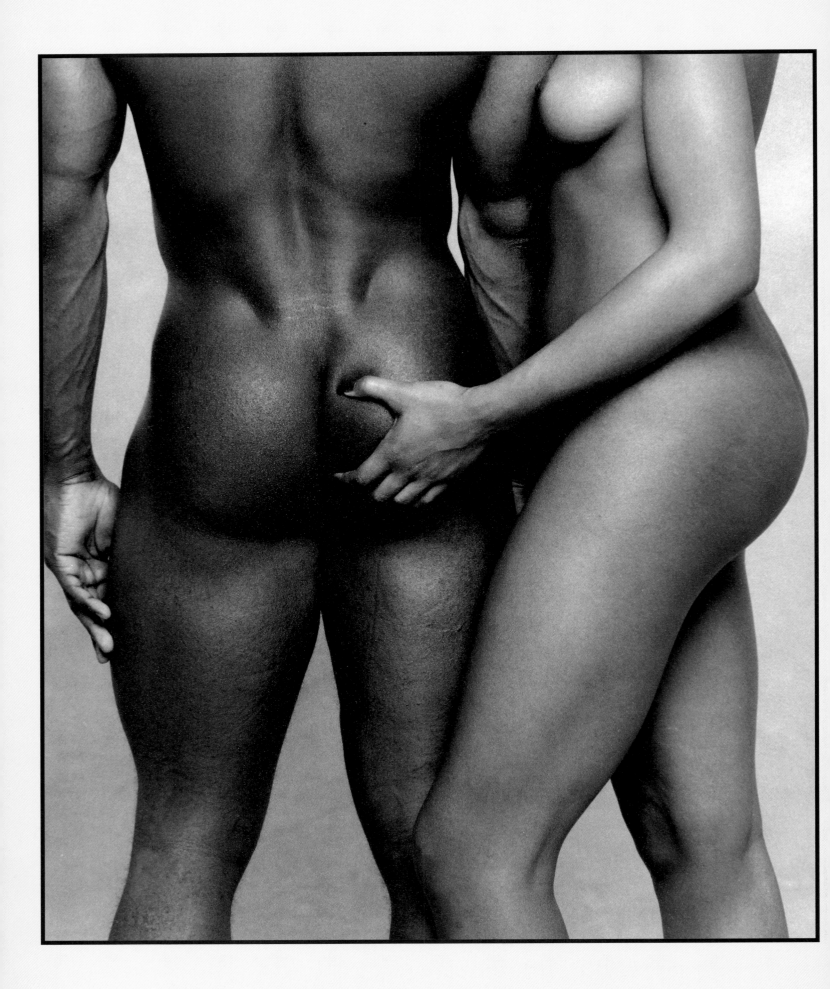

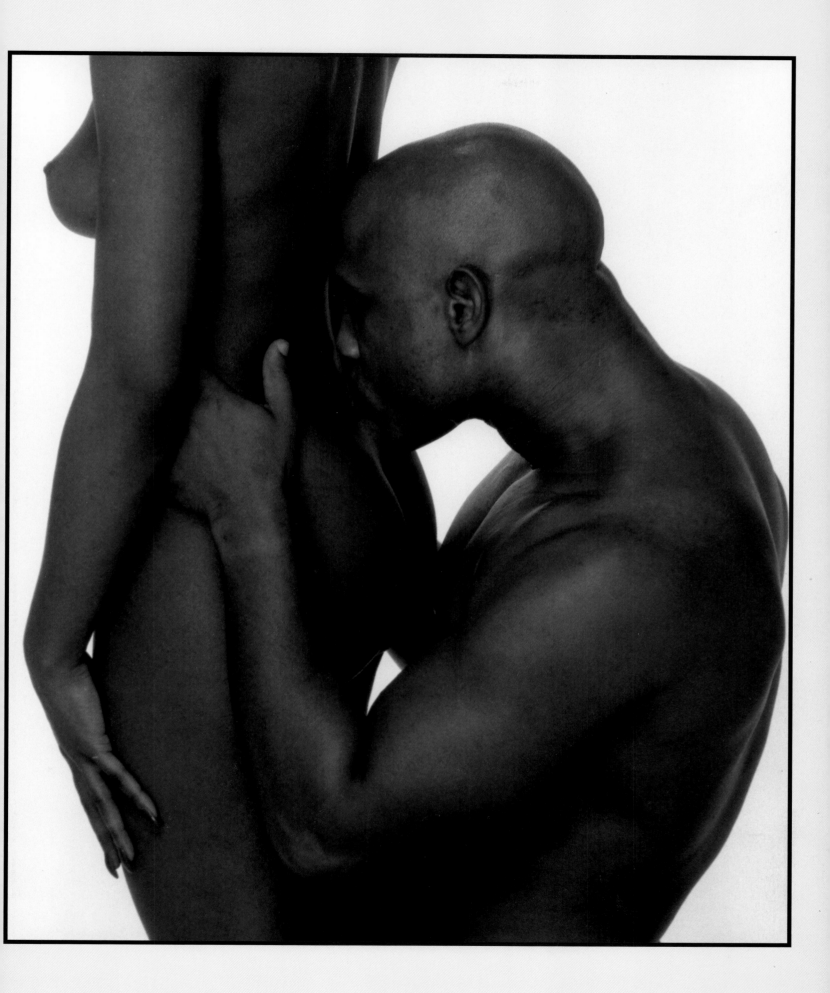

38

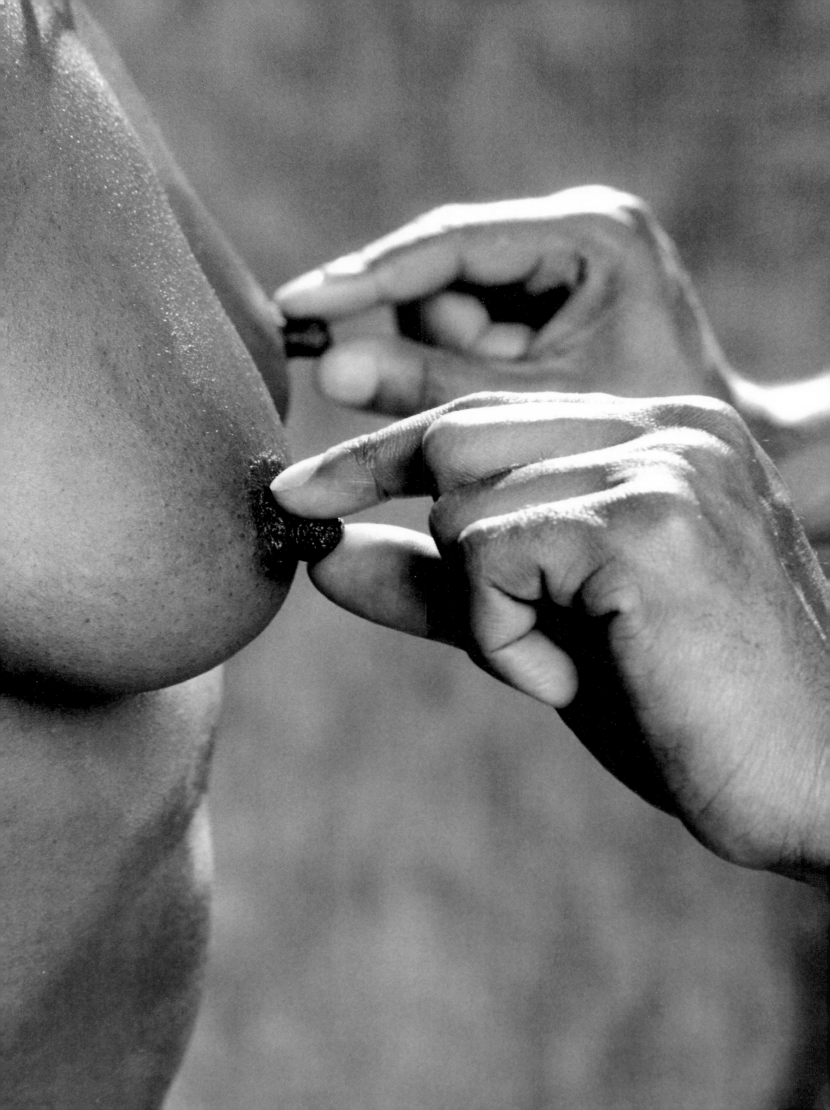

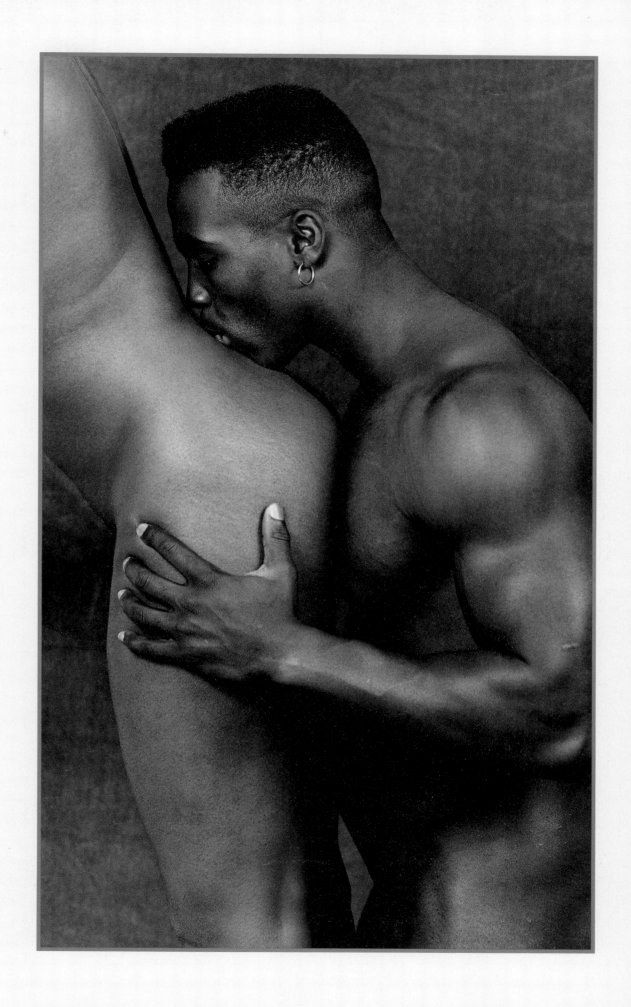

LOVE IS OUR NATIONALITY

We disregard all borderlines
when we are together
we are delicate continents clicked into place
we are uncharted territory
home to the wanderer in each of us

paperwork is unnecessary
when we are together
exchange treaties signed sealed delivered
we need no vaccination reports for our passage
passports stamped by sunrise in our eyes

we are citizens of each other
when we are together
we honor shrines with silence & flowers
we are tour guides dedicated to patient exploration
breathless travelers visiting open minds

we learn hope from one another's past
when we are together
we are sweet talking freedom fighters
we are literacy to curious children
patticake & pick-up sticks play with bilingual rules

no soldiers trample our ancient passion
when we are together
we erase our fear of fear
we stand attention without rifles
we march to the cadence of dreams

love is our nationality

our embassy safeguards persecuted touch
we are ambassadors of intimacy
we are diplomats of secret whisper
we are beauty without flags
we are emotions elected by a landslide

Peter J. Harris

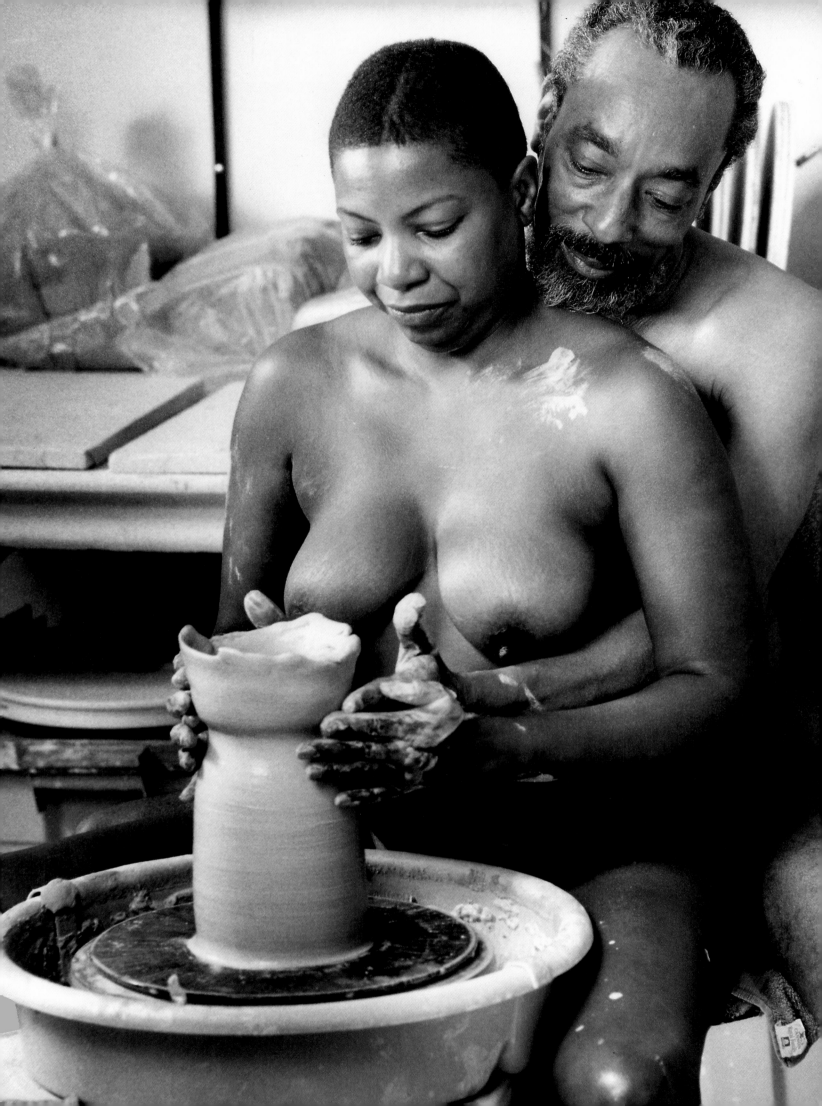

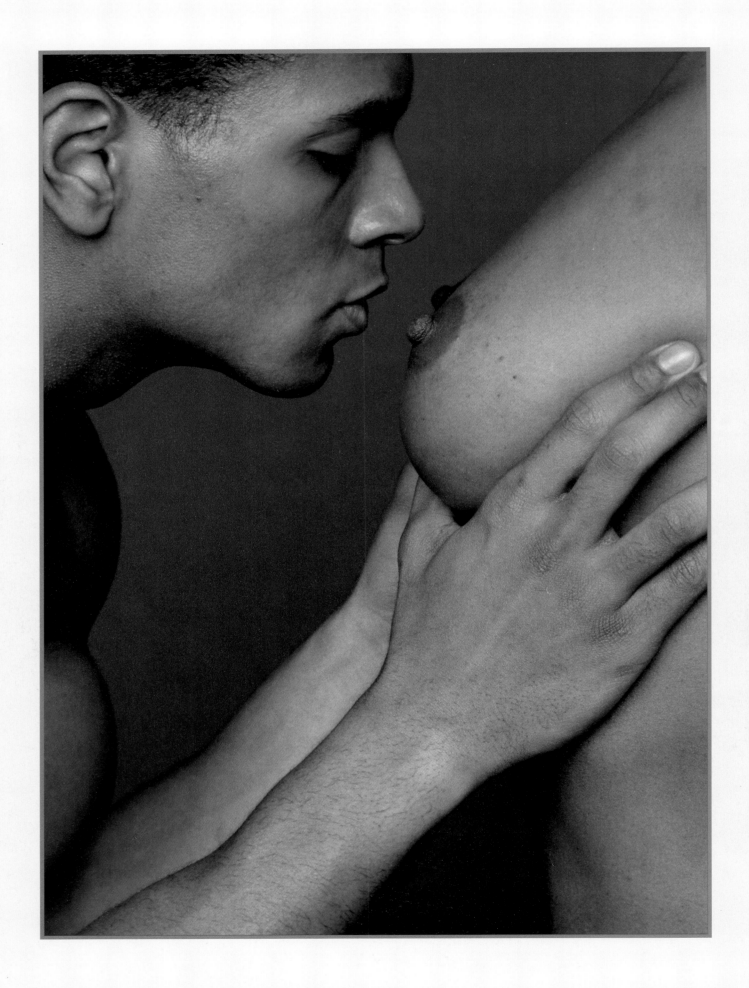

44

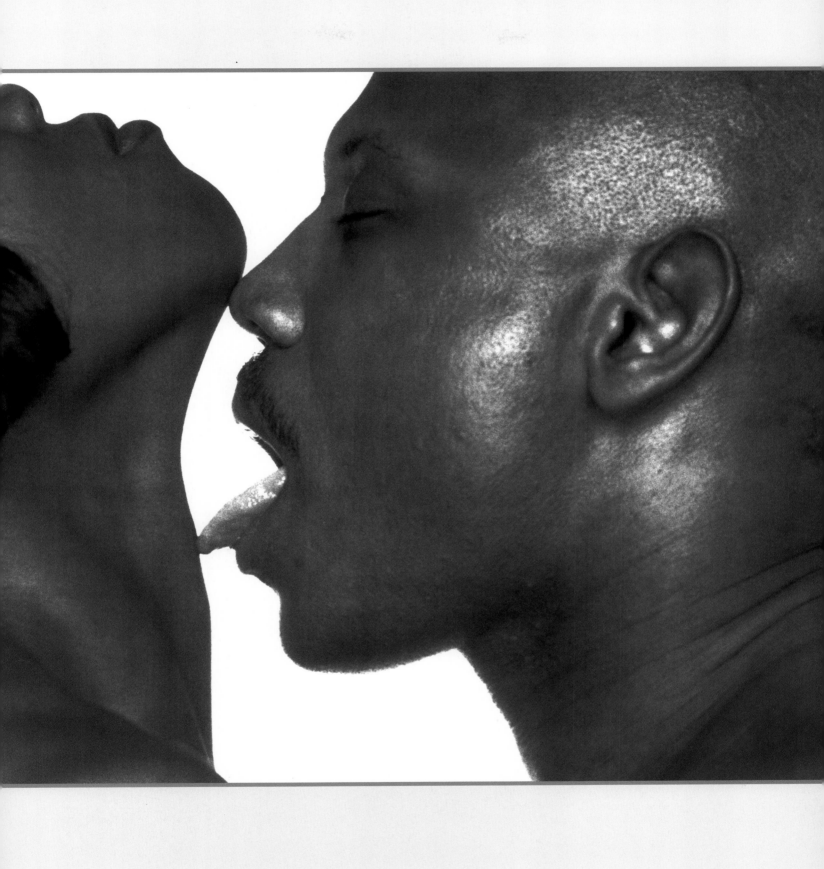

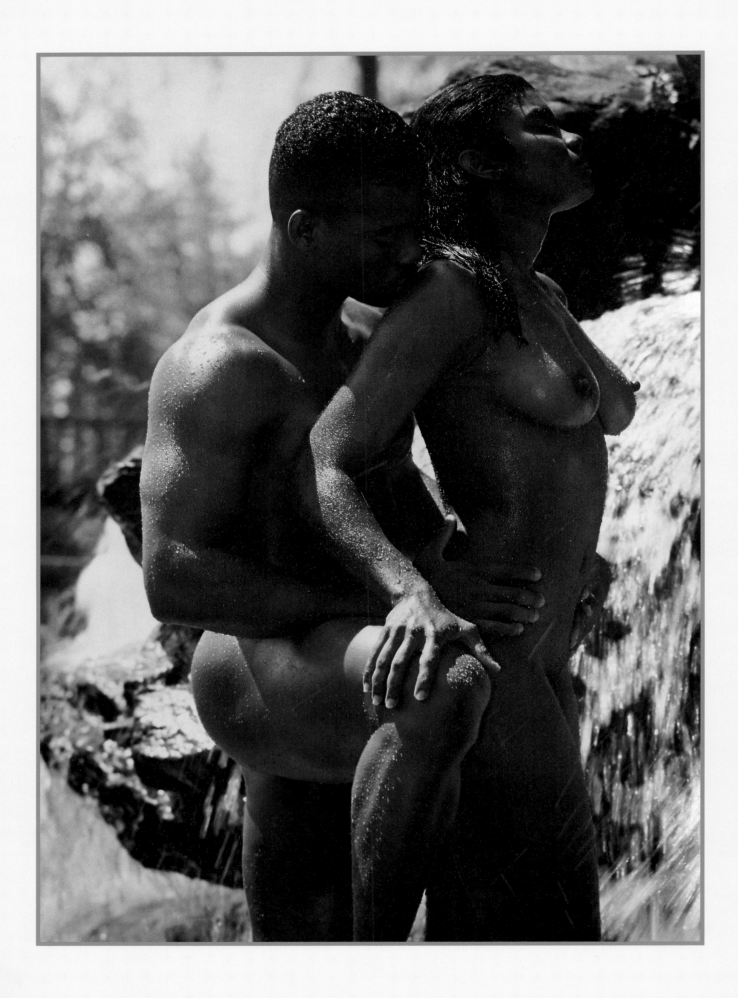

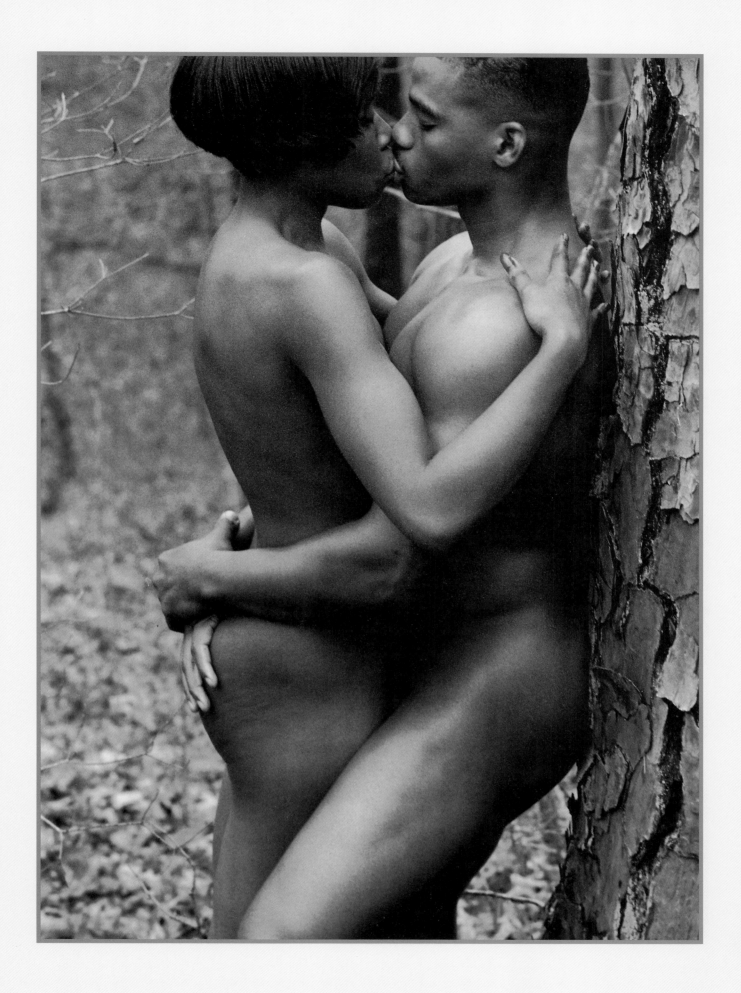

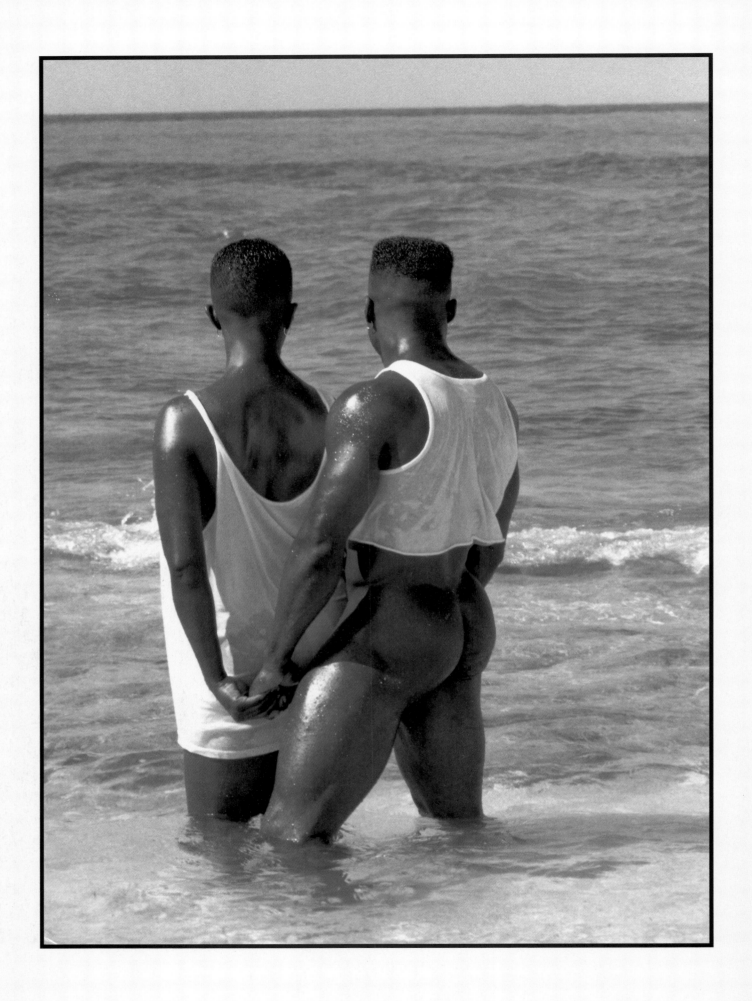

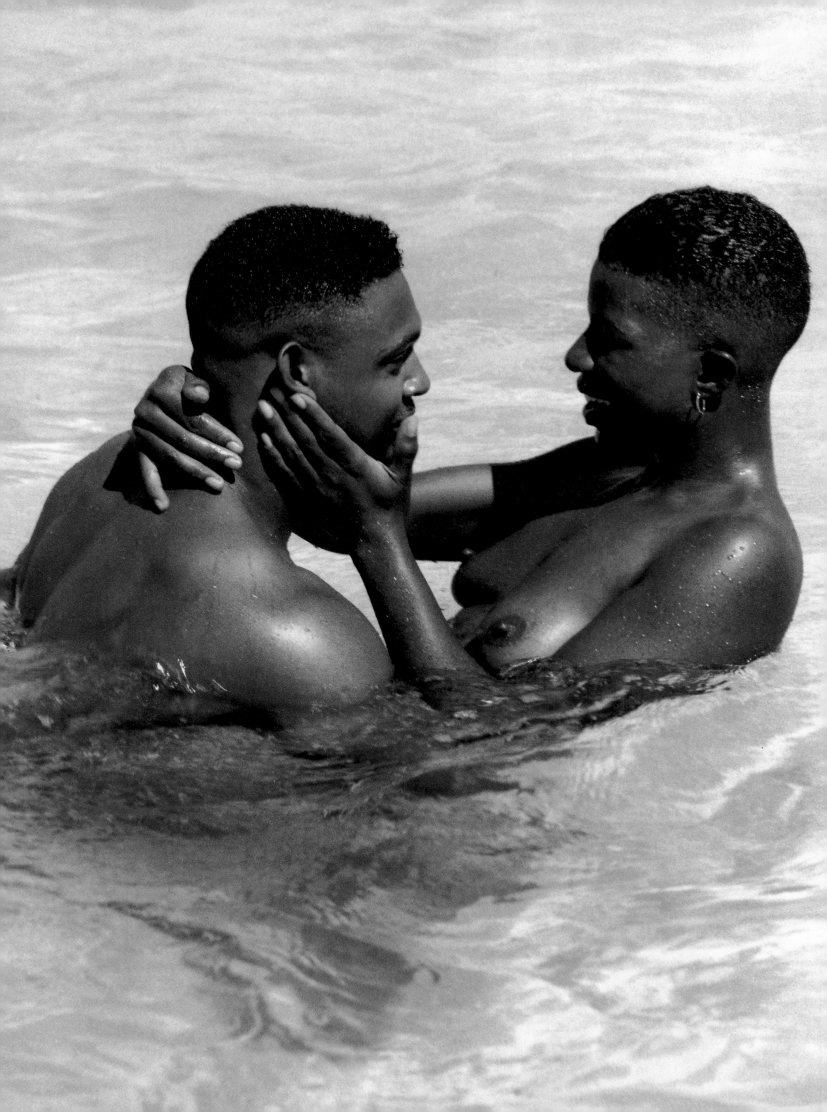

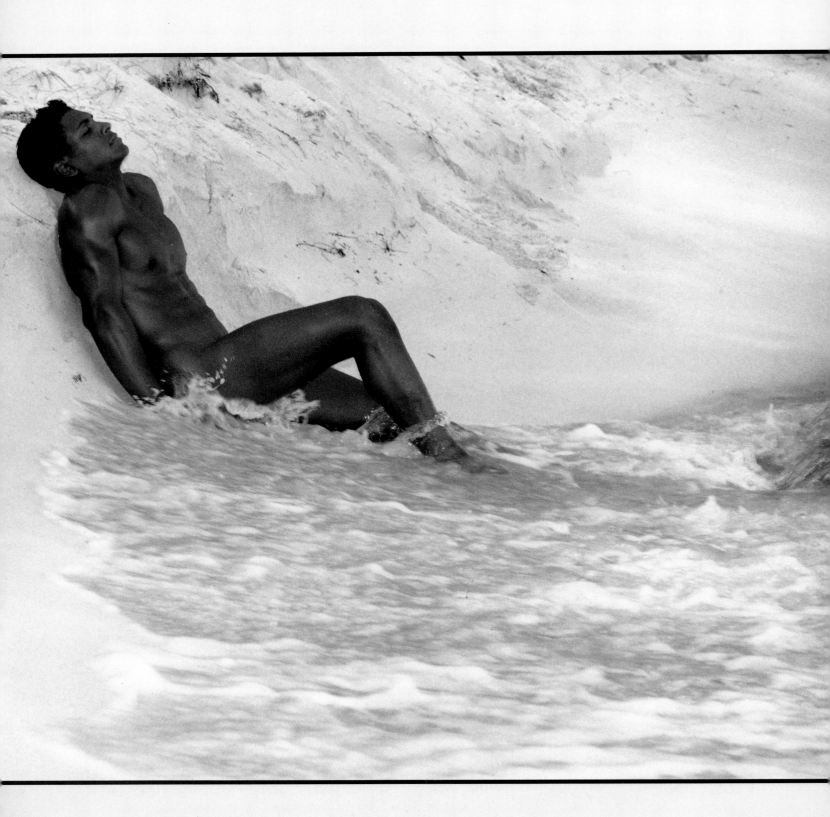

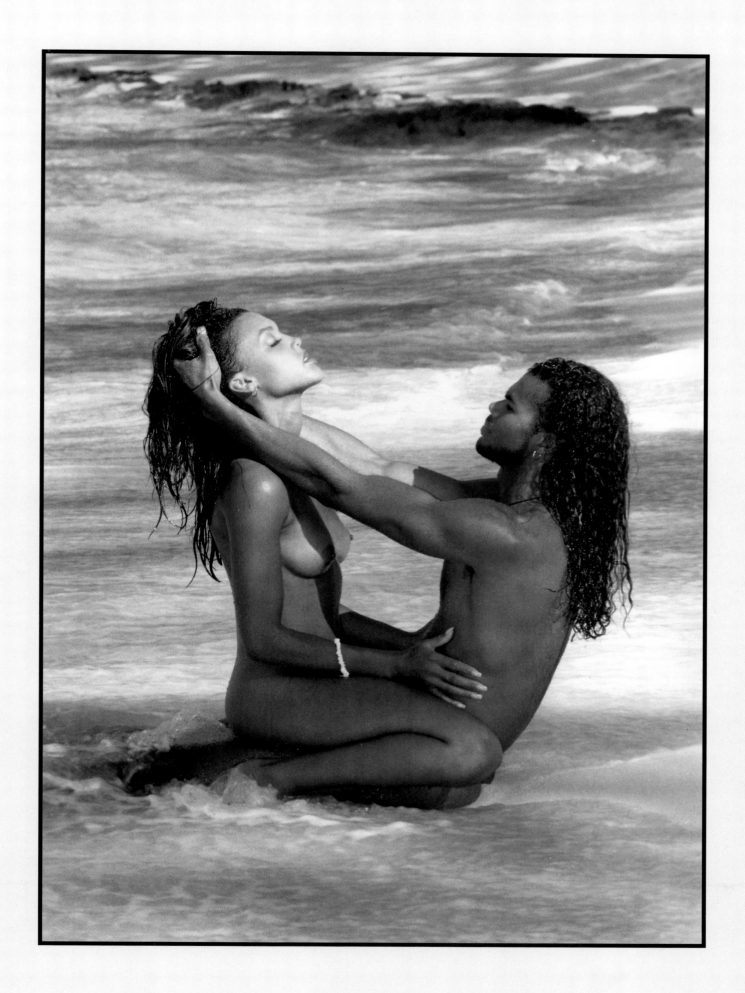

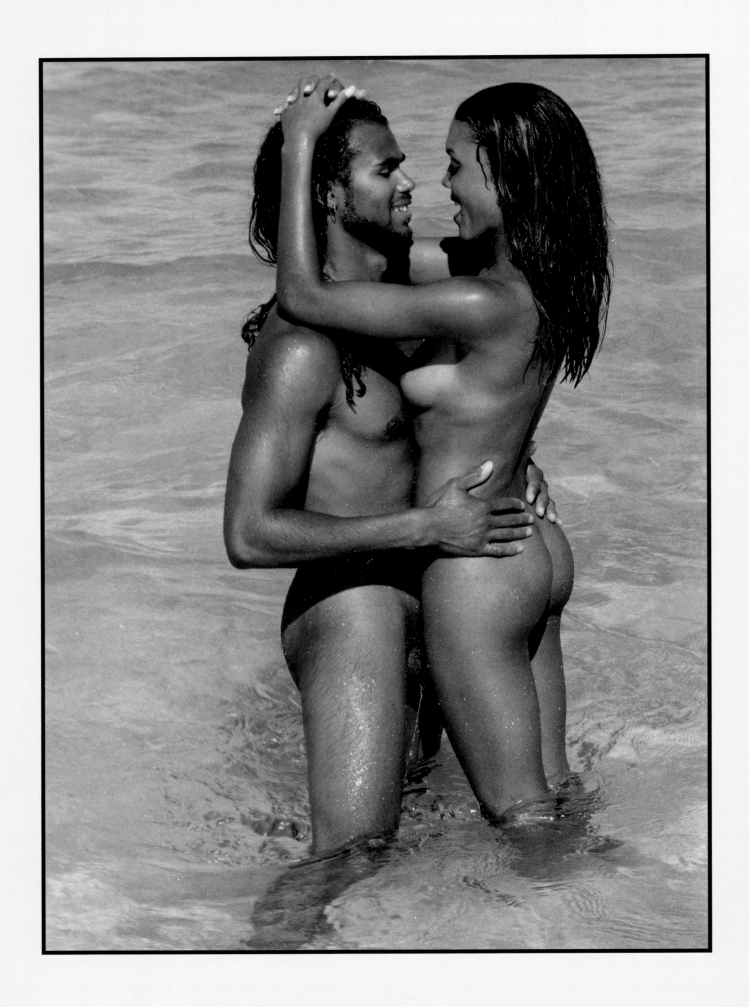

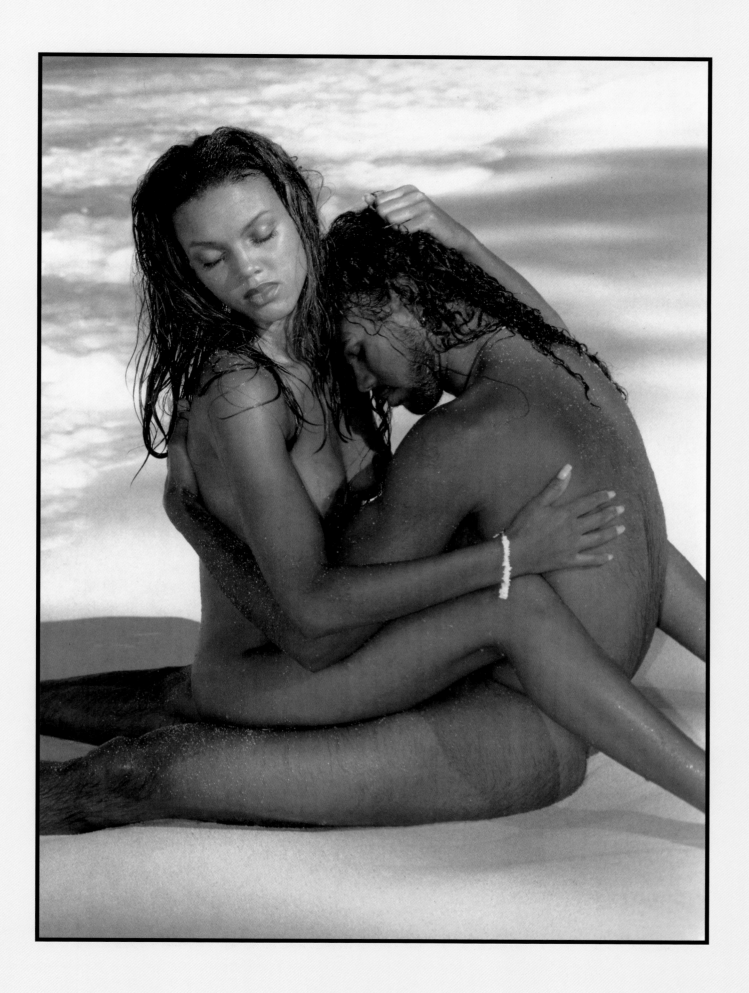

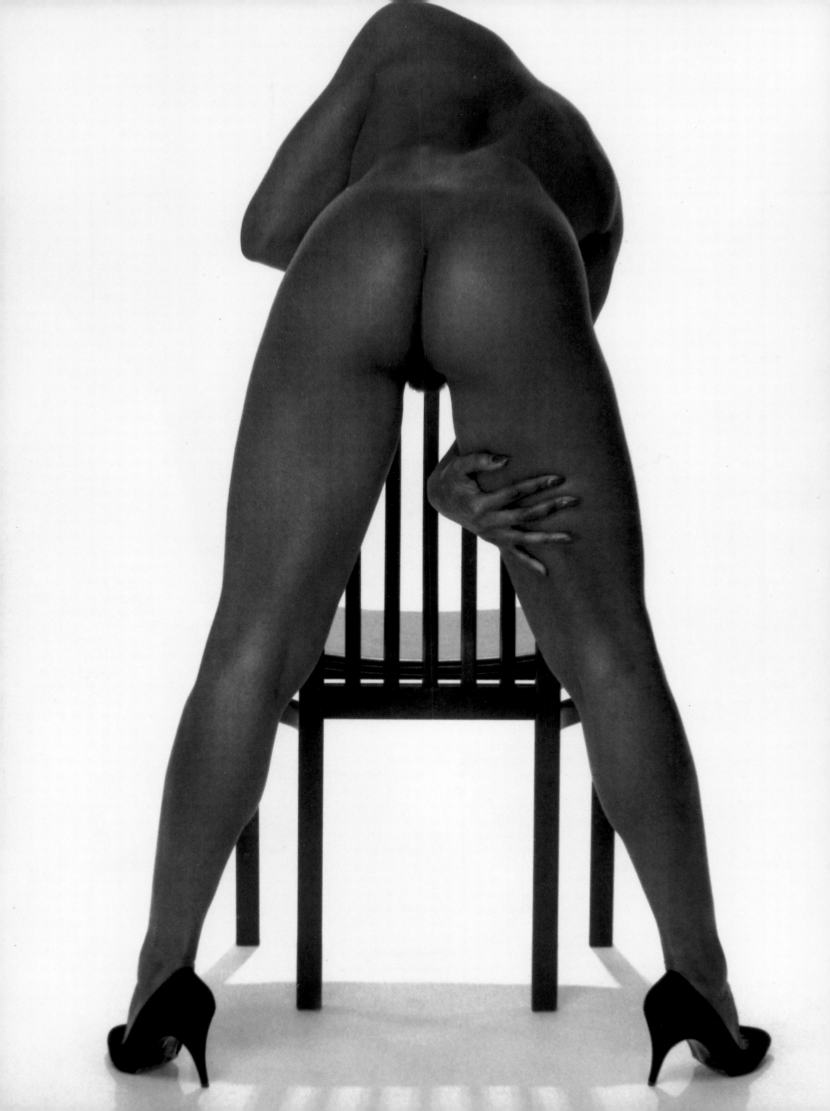

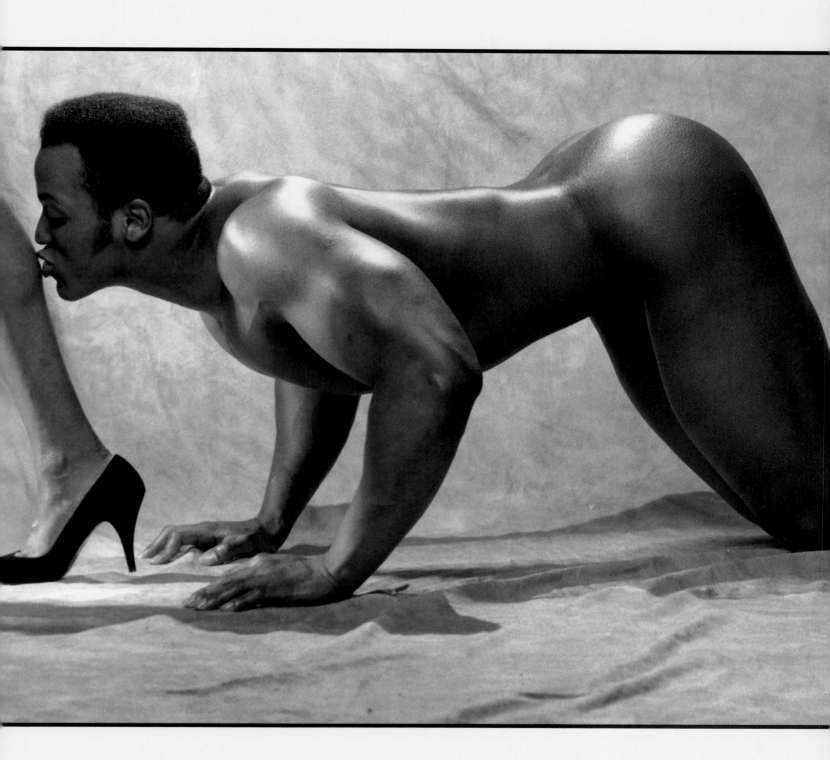

ON EDGE

We dance this dance
of wonder
(this slow groove)
slowly swaying
carefully moving
around craving
and desire
careful not to
step
too close
to the edge
the fall is fast
and liberating
but not free
and i cannot fly
not here
not yet
we kiss
once
our tongues
have wings
they dance
whispering
slowly swaying
carefully flying
inside craving
and desire
trying to seduce
the heart
and the body
and the soul
to join this groove
to fly

Michael Datcher

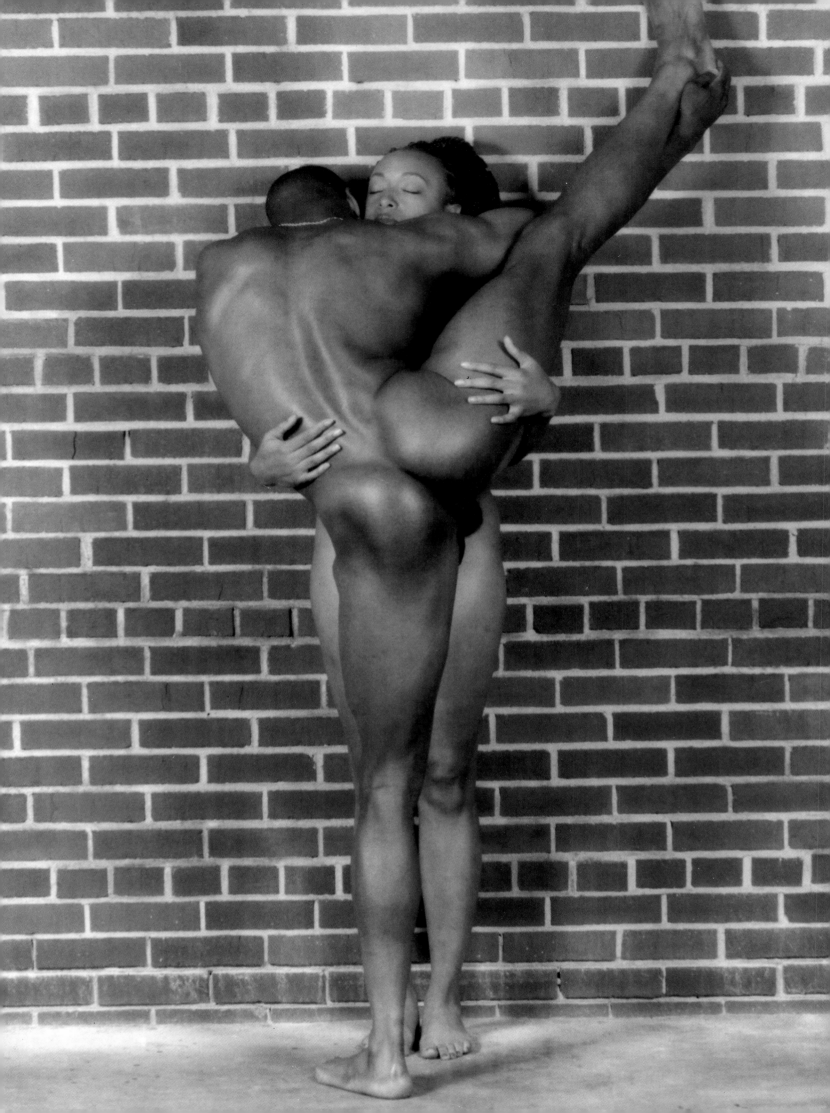

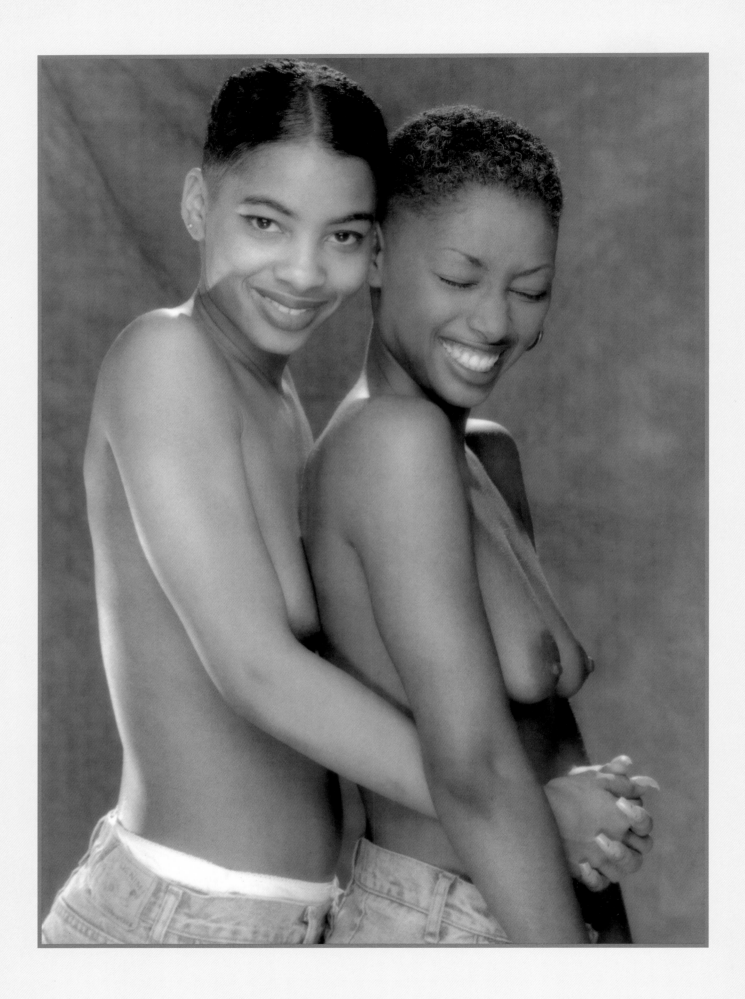

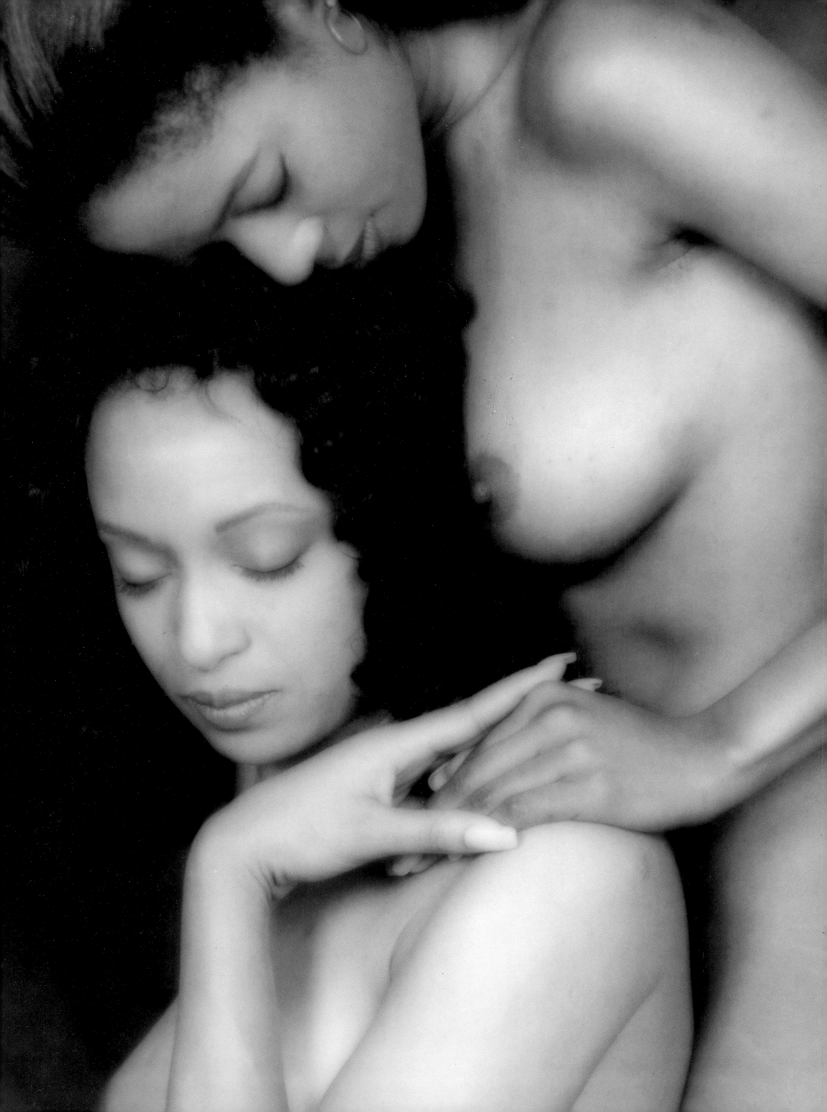

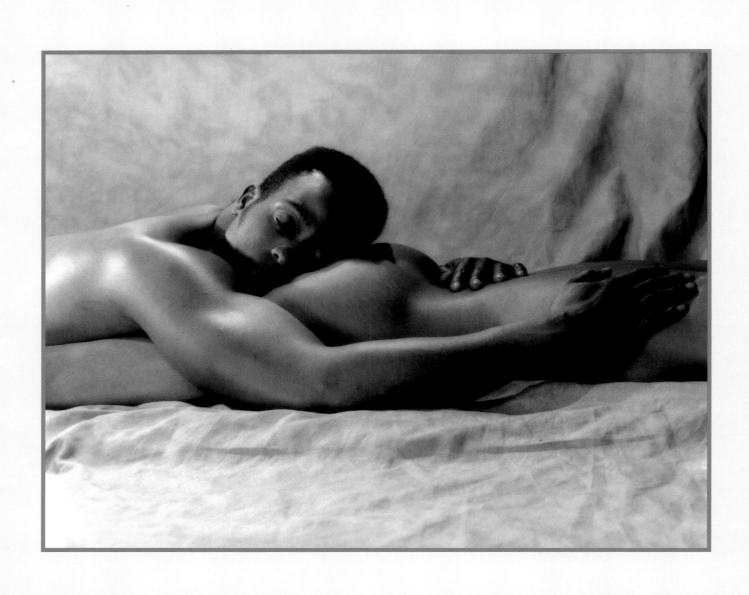

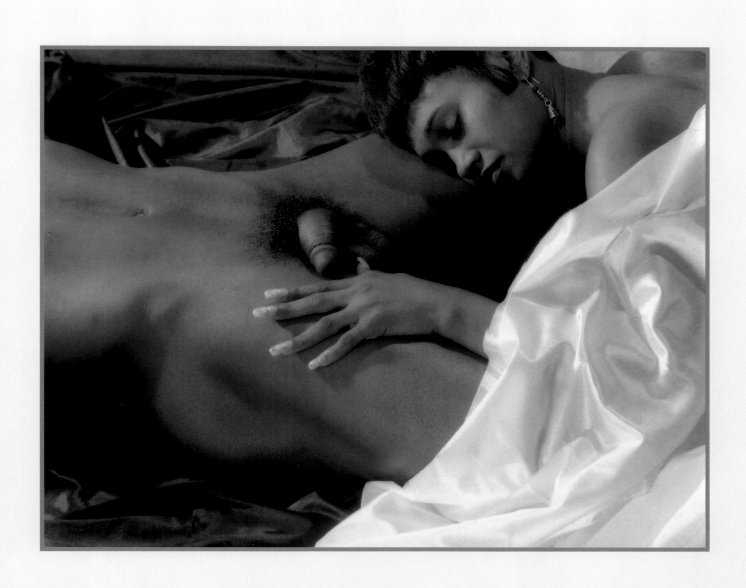

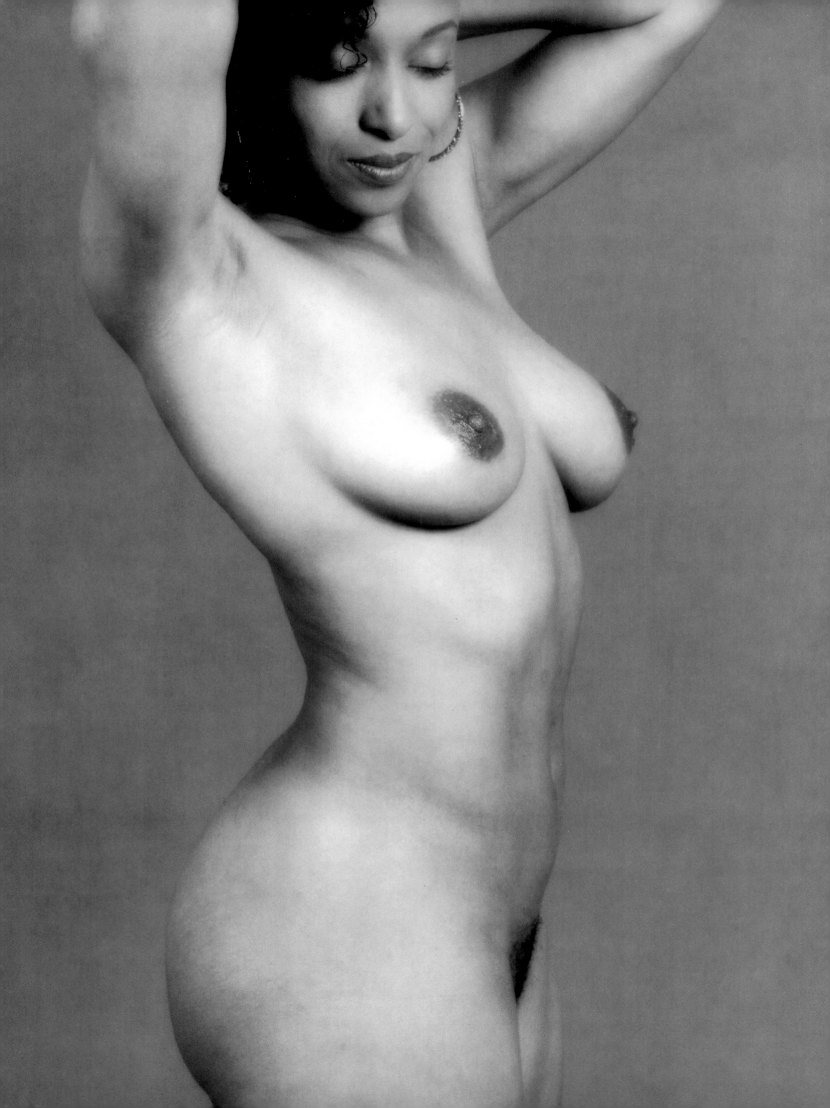

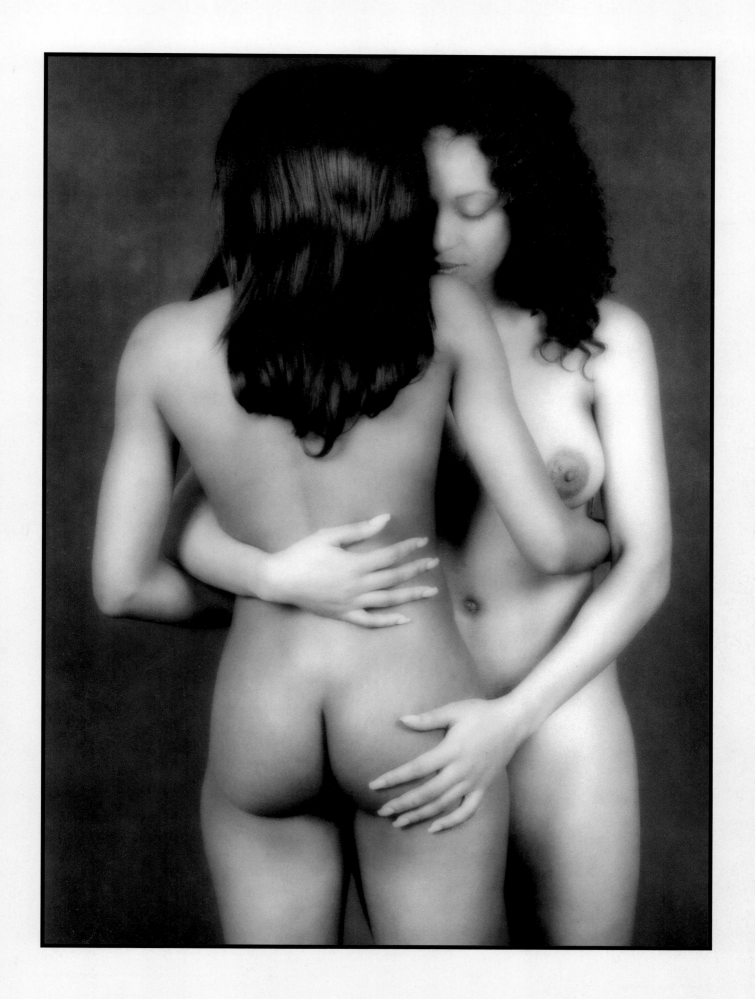

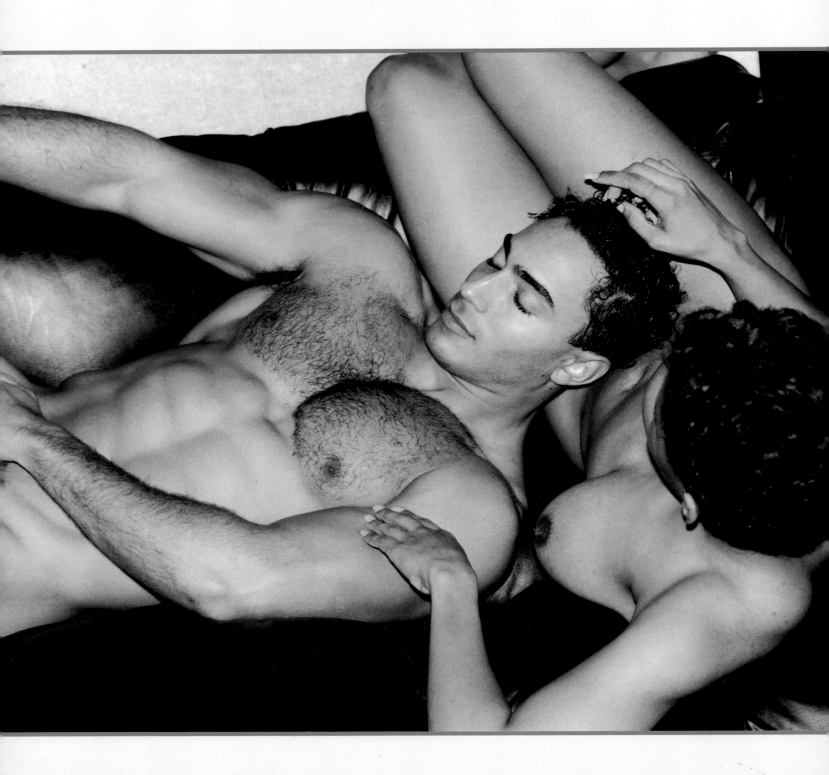

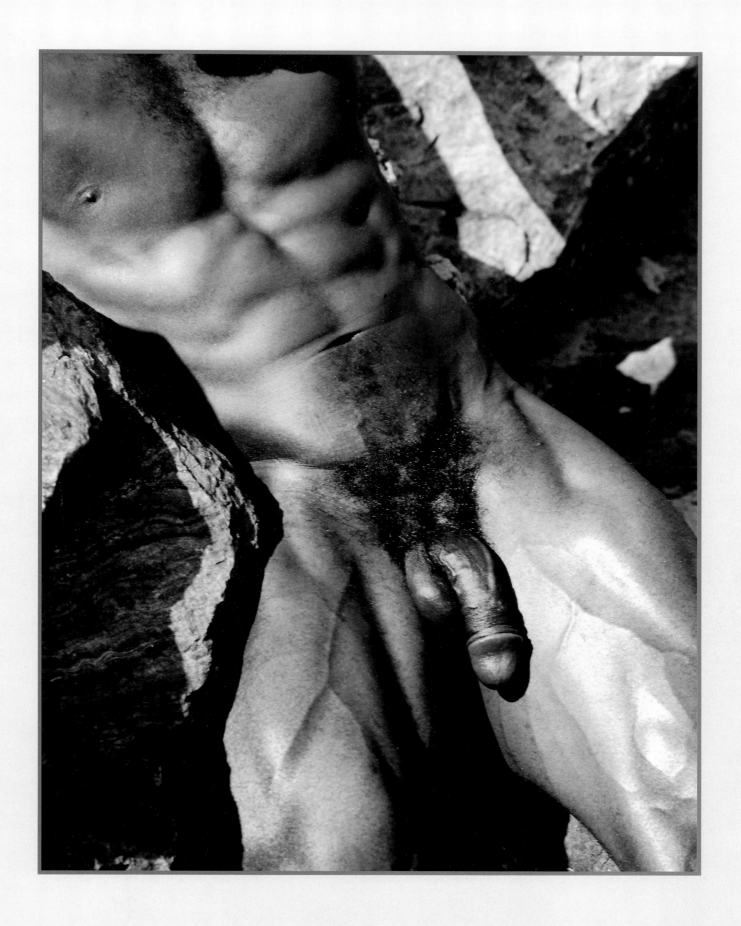

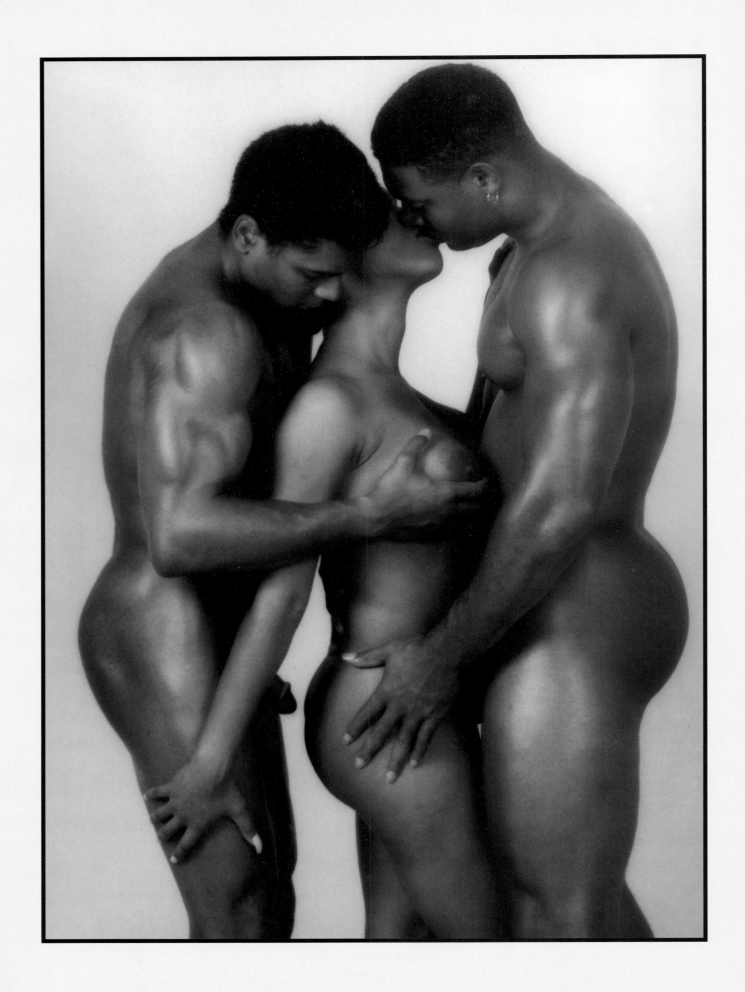

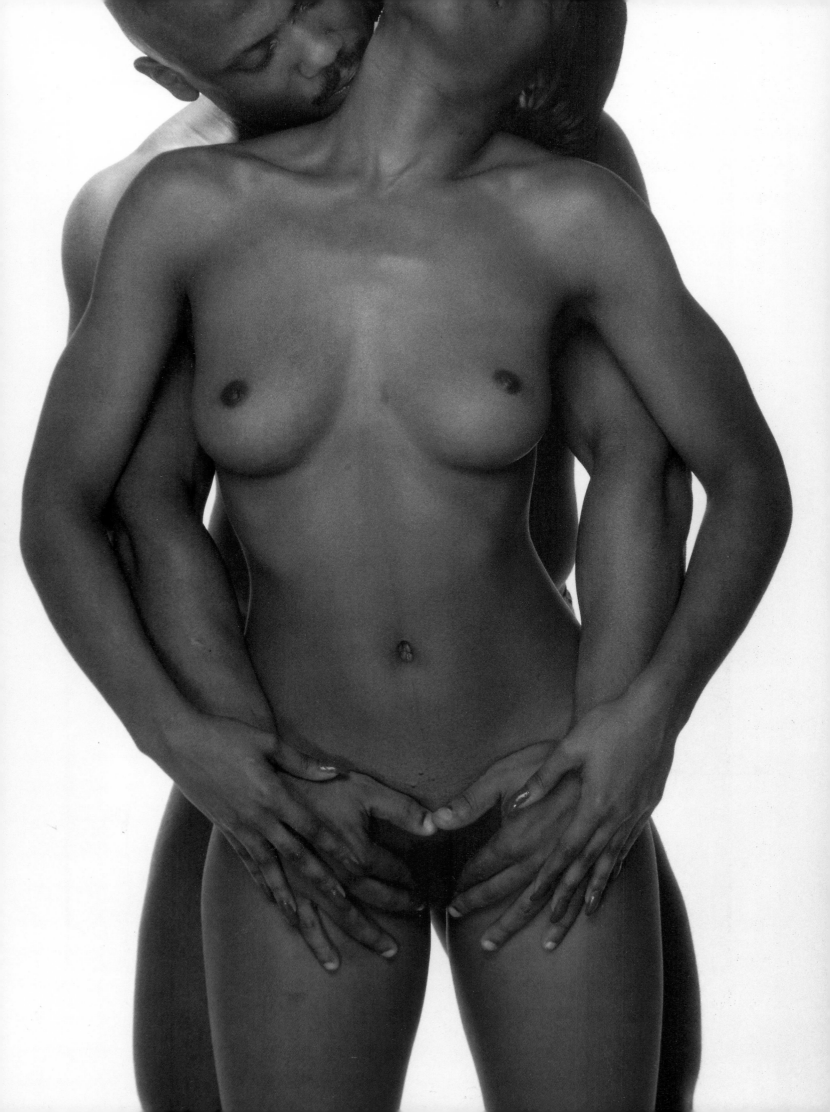

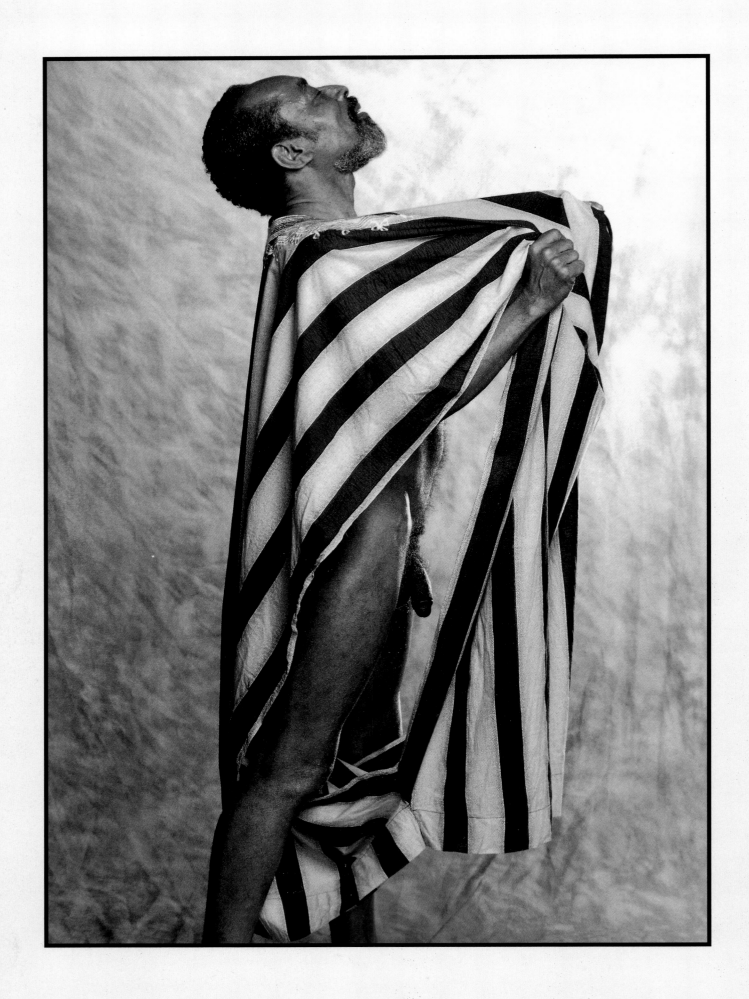

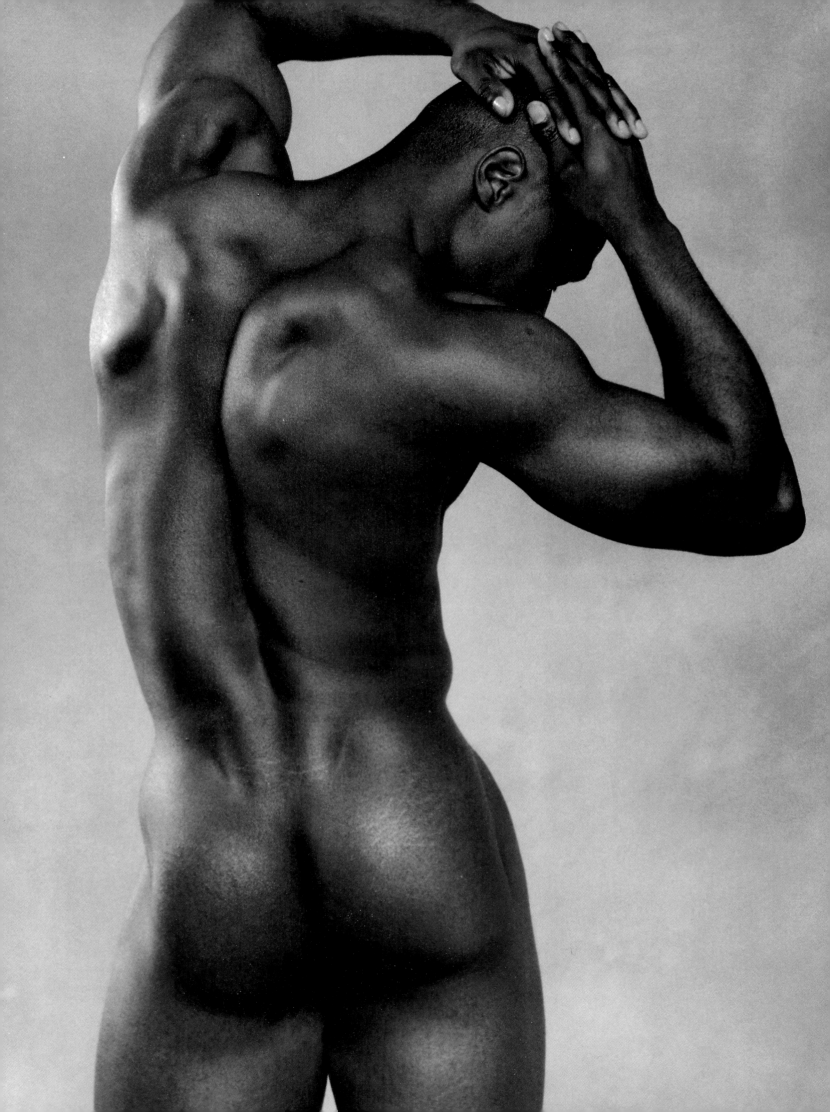

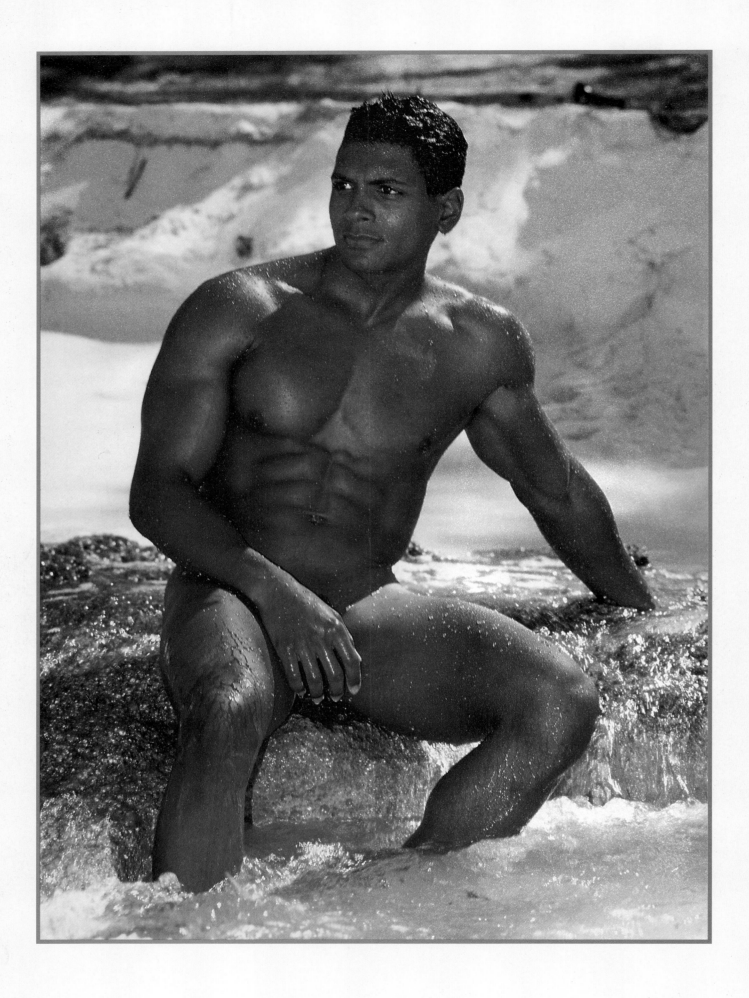

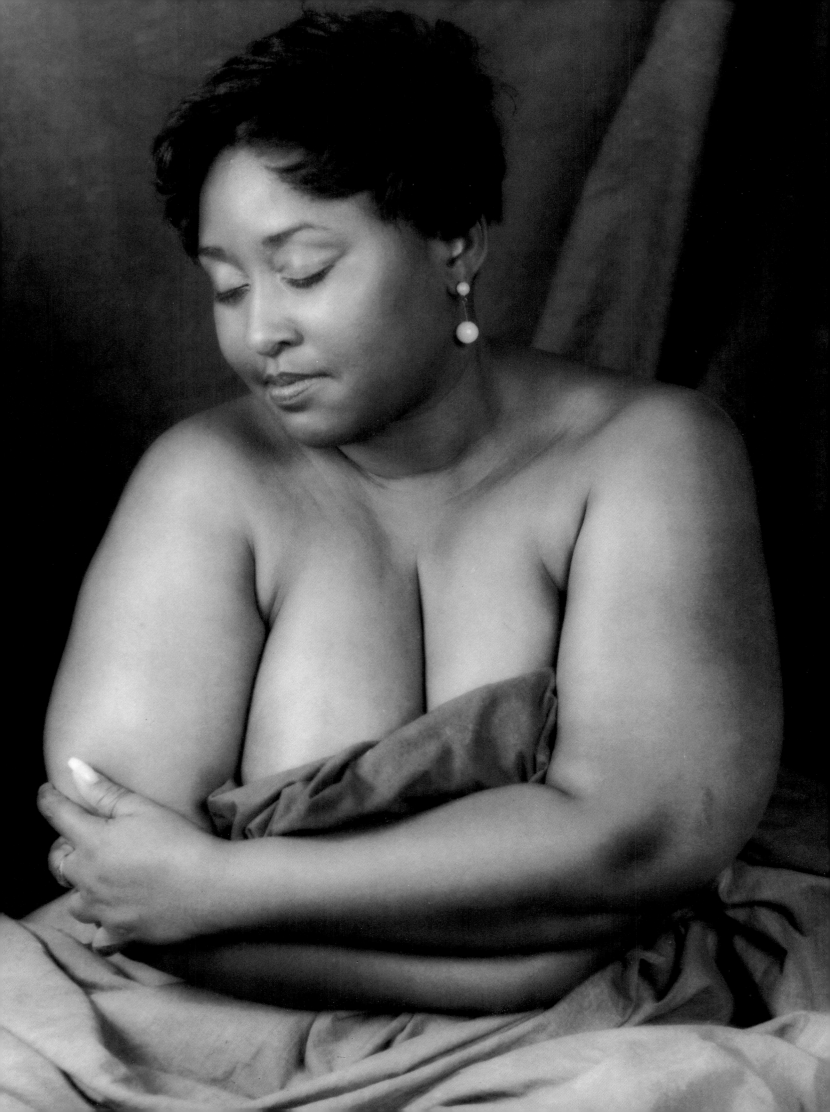

THE BEACH WITH OKRA & GREENS/
On Their Honeymoon/Banda Abao, Curaçao

It be hot & then again not
breeze know how to cool
the burnin
when the sun force us to twitch
punctuate the air
wit alla this the breeze she
fan our behind/ tickle the bosoms let the music
free out out soul rush
up from waves no matter
no matter the seaweed tease
thru legs make us want make us want
to swing with the horizon
so easy so easy to swim to swing
to stroke hard to breathe deep
but the sun she want us to twitch
she love to watch us sway alla sudden
throw the leg round there/ hips put so to the sun
winds like opium lovers/ the winds get in our blood
run us to the sea/ the sea she want it all
the sun she want us hot
but it be hot & then again not
the sea she want it all
& she keep comin back/ she like our toes earth tanglin
 wet like
but the sun she want us hot so/ but it be hot
& then again
not cuz the sun she want it all.
& we be it/ ras man/ sun/ so . . . / hot.

Ntozake Shange

72

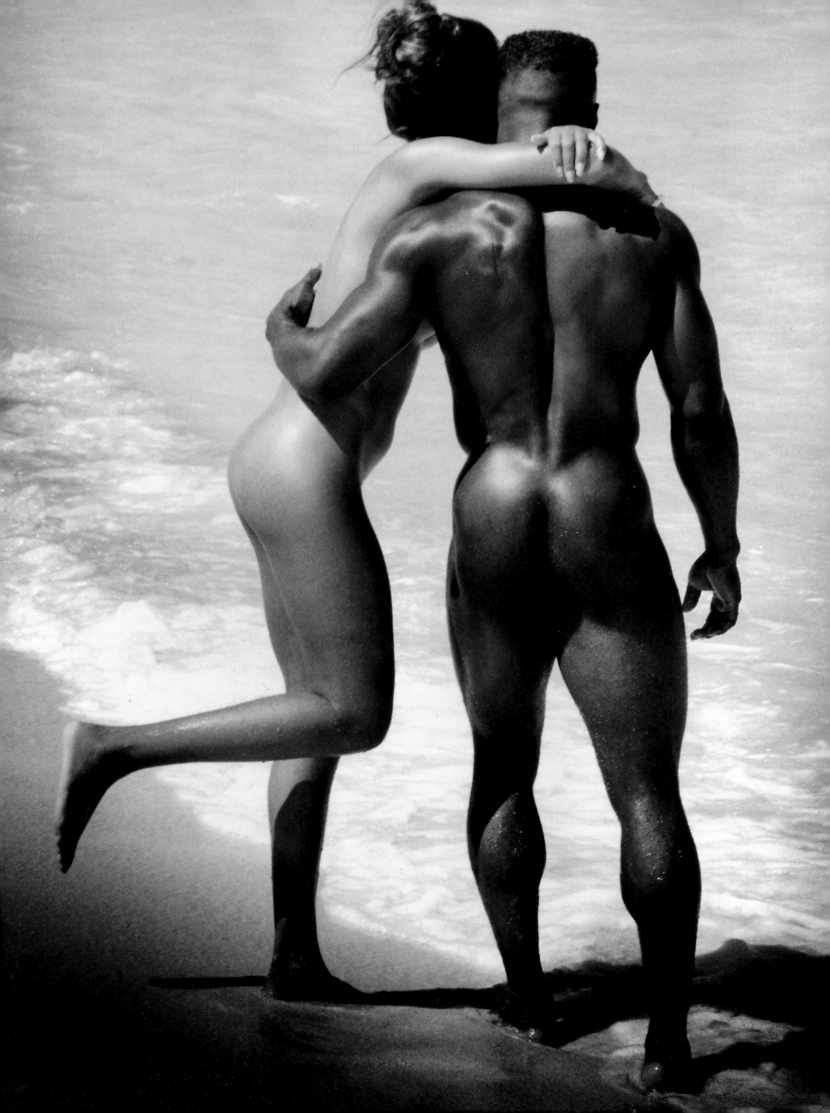

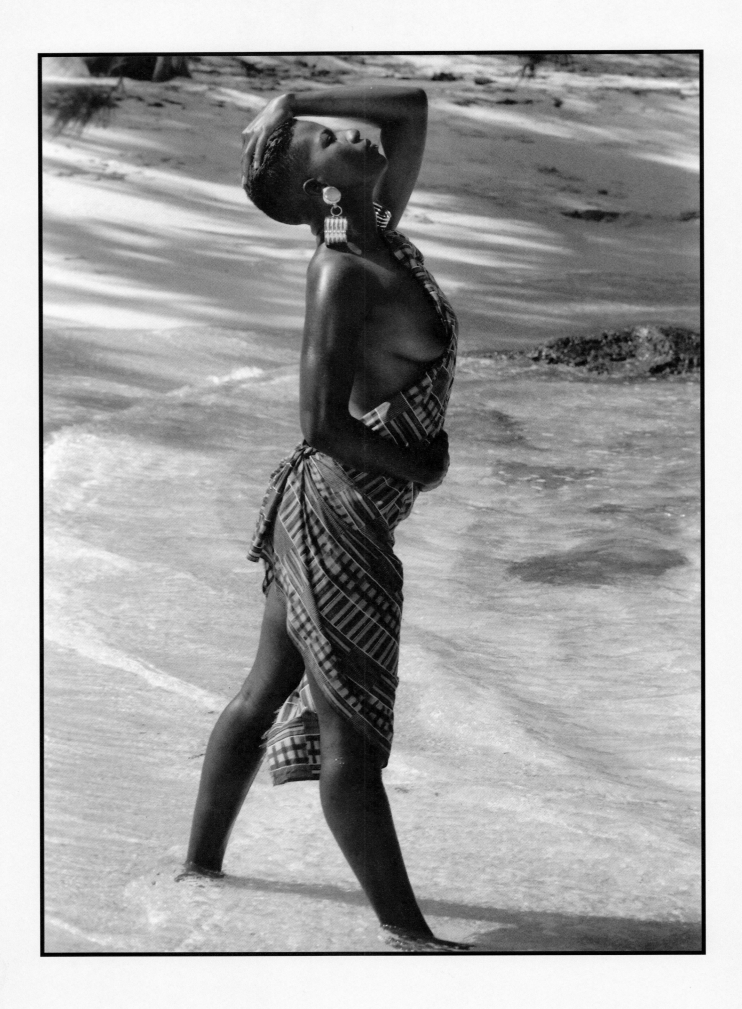

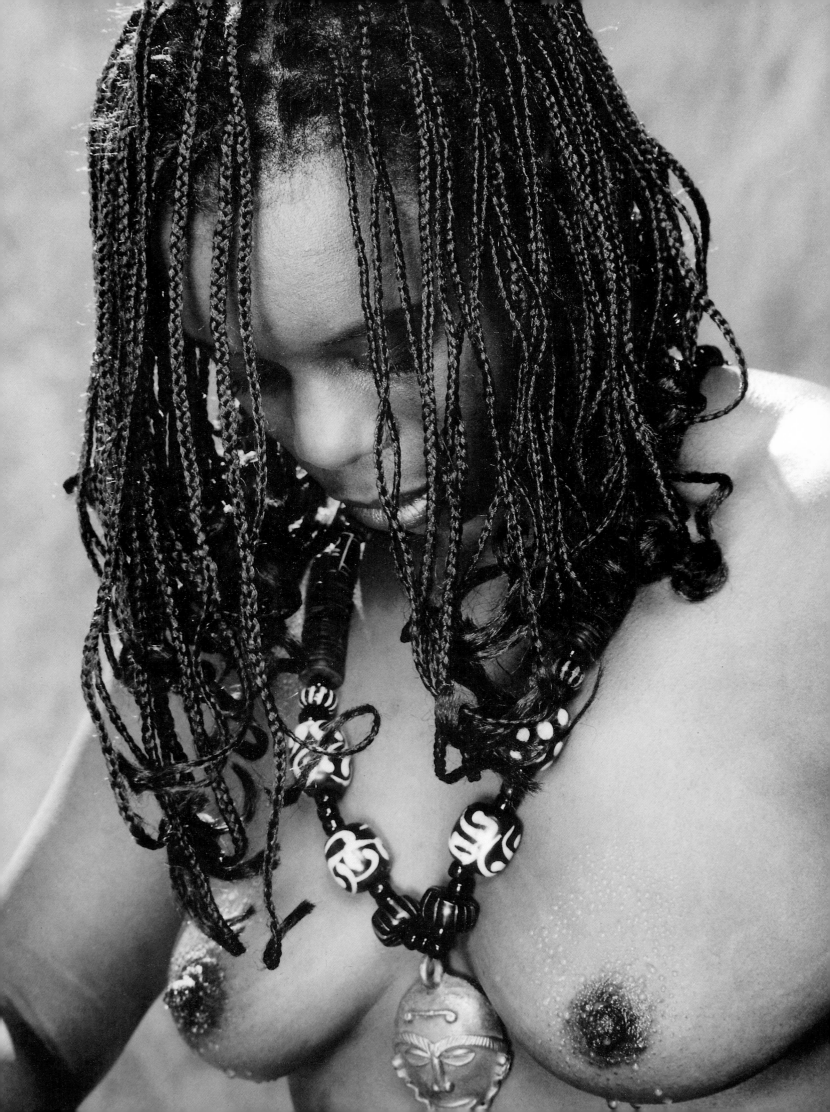

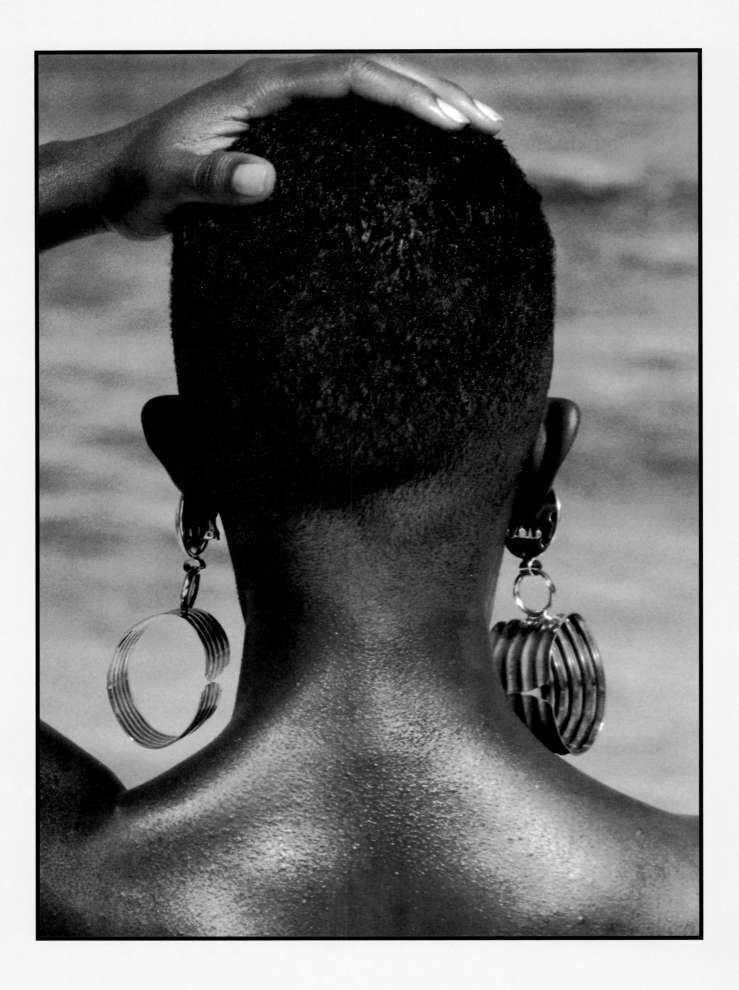

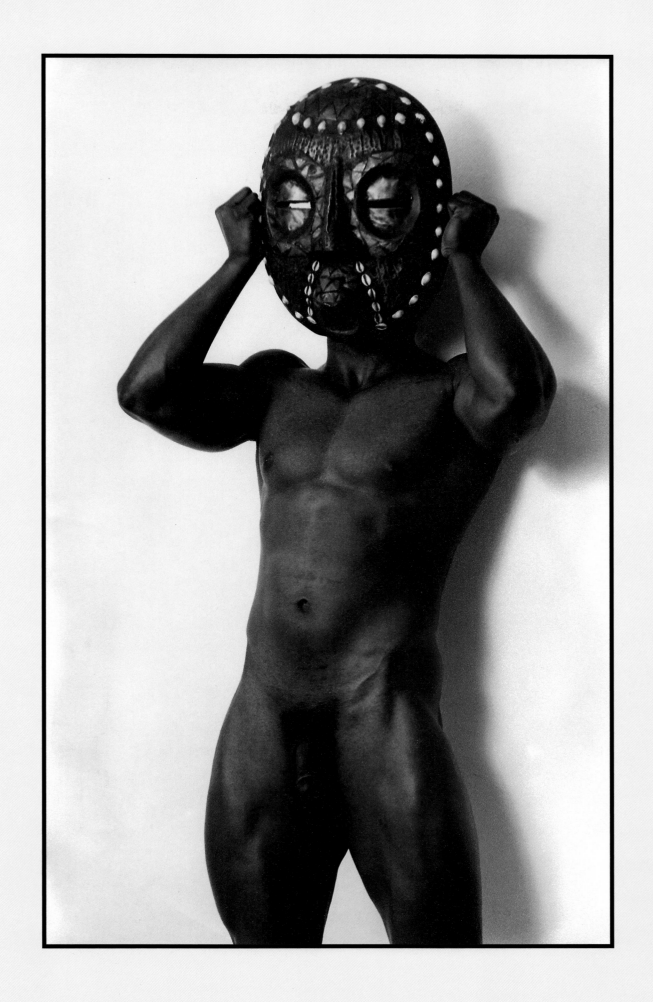

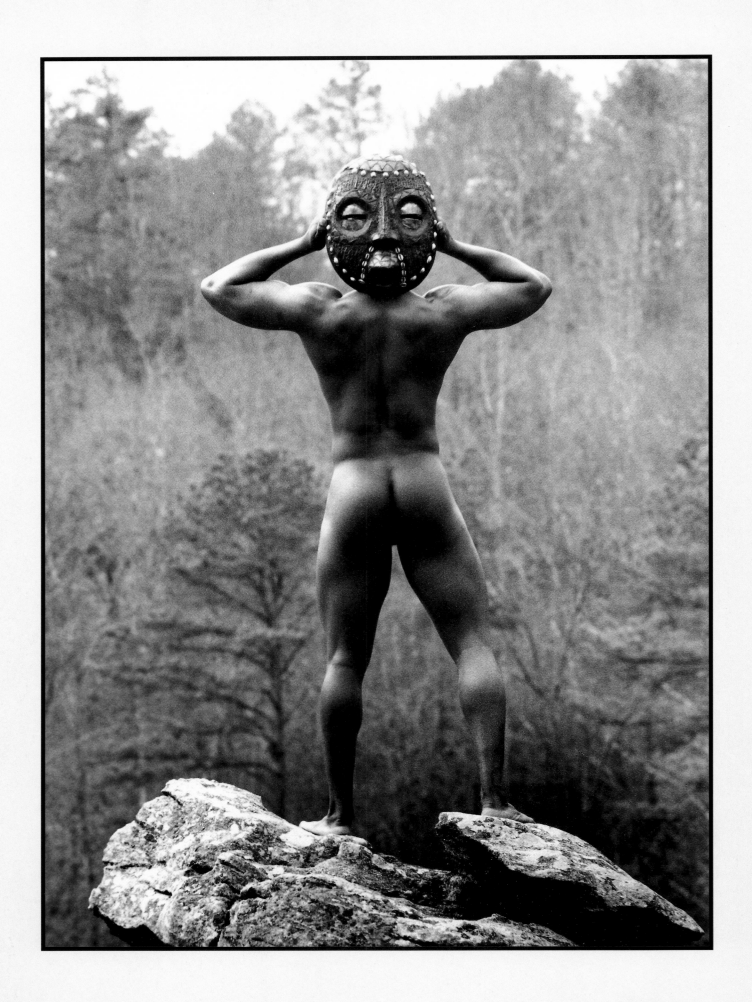

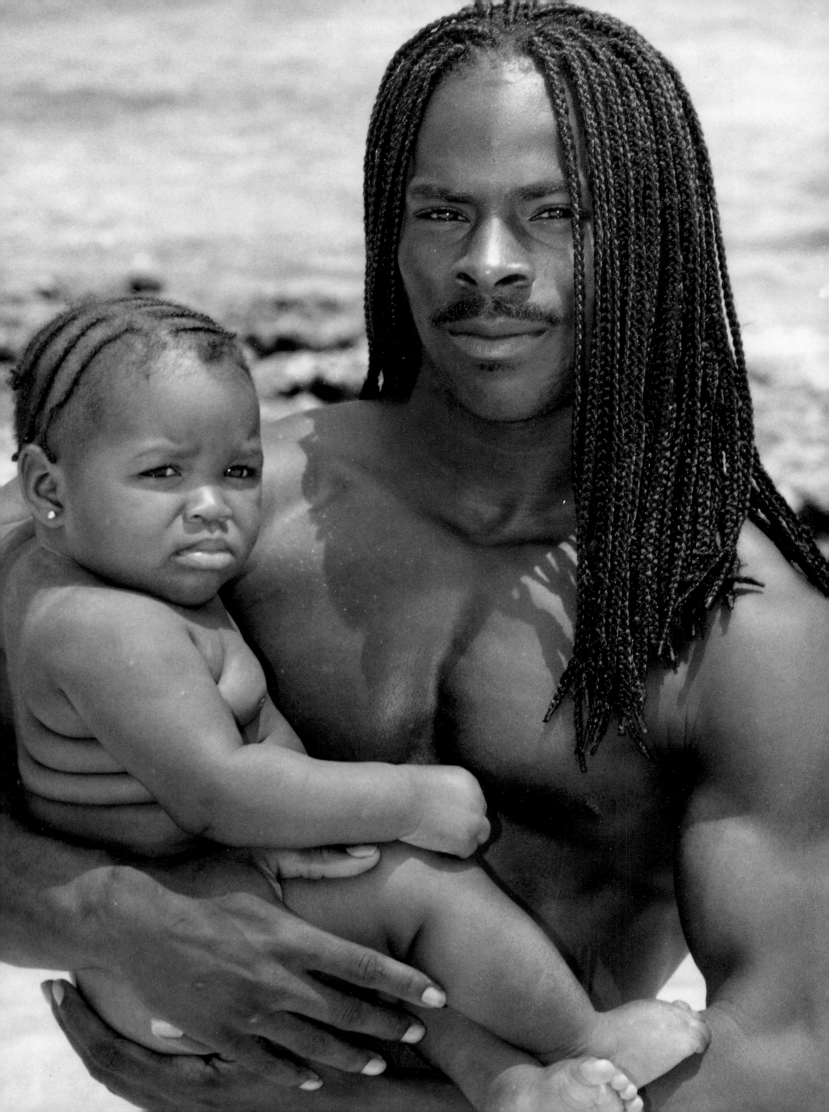

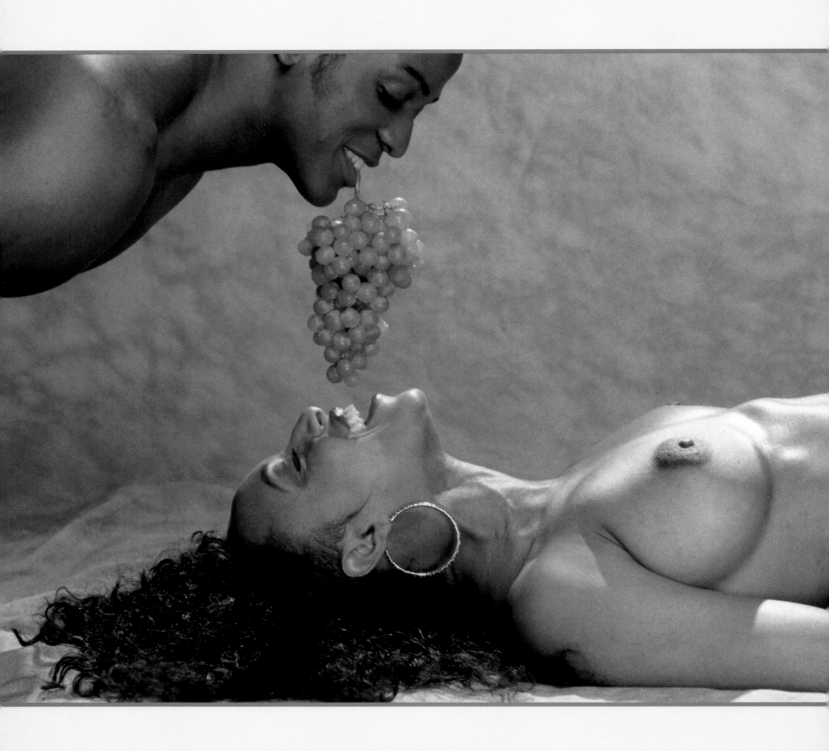